Spring, 2000

Enjoy this book as you find out all about your interests in Florence! And then tell me what you learned! :)

Love always,
Nancy

Title: The Medici. Story of a European Dynasty

© 1999 **La Mandragora s.r.l.** All rights reserved.
piazza Duomo 9, 50122 Firenze
www.mandragora.it

Editors	Monica Fintoni, Andrea Paoletti
Translators	Christina N. Caughlan, Andrea Paoletti
Graphic Design	Laura Venturi
Photography	Mandragora Archives, Antonio Quattrone, Niccolò Orsi Battaglini, Marco Rabatti, Fabio Lenzini
DTP	Franco Casini

Printed in Italy by Giunti Industrie Grafiche, Prato.

ISBN 88-85957-36

This book is printed on TCF (totally chlorine free) paper.

Franco Cesati

THE MEDICI

Story of a European Dynasty

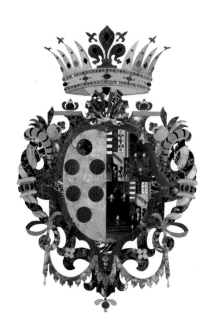

Mandragora

Preface

The Medici are the best-known and most prestigious Italian family, their name inextricably linked to the history of Florence. The city itself remains a living symbol of the peninsula's most splendid epoch: when people around the world think of Italy, they usually think of Florence and Tuscany, and of the priceless art collections that hold to this day an irresistible fascination for millions of visitors.

The Medici ruled Florence for three hundred years, though shifting political fortunes periodically forced them to step down from power. From Cosimo the Elder (1389-1464) to Gian Gastone (1671-1737), the family and their city lived through an age of splendor and an age of decline. In the end, Florence – like Italy itself – wound up on the fringes of a new Europe: one defined by nation states and a budding market economy.

To understand how this obscure family from the Apennine valley of Mugello obtained their remarkable success, we turn first to Medieval Florence, and in particular to the phenomenon of "city-state civilization" so characteristic of Italy during the 12th and 13th centuries.

Florence before the Medici

In the 11th century Europe seemed to awaken from a long spell of lethargy. Its economic, political and social life, limited for centuries by the rigid confines of the court, found a fertile new hub in the cities. This remarkable process of civic rebirth did not come, however, without its traumas…

Independent city-states and clashes with the emperor

Cities throughout Europe, having been of negligible importance during the early Middle Ages, experienced a progressive rebirth following the year 1000. In Italy the revival of civic life was much more animated and profound than elsewhere, to the point that even today the peninsula is characterized as "the country of a hundred cities." Starting in the 11th century, various urban centers assumed ever-increasing importance: Venice, Genoa, Pisa and Amalfi – the so-called "maritime republics" – followed by Milan, Bologna, Ferrara, Lucca and, naturally, Florence. Faced with the crisis of imperial authority, these and many other cities – often diocesan centers, mostly concentrated in Northern and Central Italy – began to appropriate some of the powers that in theory belonged exclusively to the emperor.

By uniting on the basis of an oath, the most influential families (essentially the nobility, at first) began taking control over various functions of government: establishing a police force, imposing taxes and fines, collecting duty at the city gates, maintaining discipline among the merchants, minting coins.

During the 12th century, however, the Empire reacted to this rise in civic autonomy. The German Emperor Frederick I of Hohenstaufen (known as "Barbarossa" for his distinctive red beard) entered Italy to restore the cities' obedience with the force of arms. His attempt failed before the resolute reaction of the cities: in 1176 the Lombard city-states, joined together in a league, managed to defeat the imperial forces in the field battle of Legnano. Although the emperors that succeeded Barbarossa did not

The **basilica of San Miniato** was built between 1018 and 1027 by the Cluniac monks. During the siege on Florence in 1529, the hill on which it stands was fortified by Michelangelo.

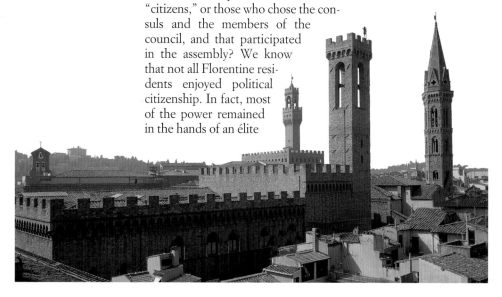

Right: The **Mannelli tower**, located near Ponte Vecchio. During the Middle Ages, noted Vasari, "everyone went about busily fortifying their homes for their own personal security." However, a civic ordinance was passed in 1250 that limited the height of any given tower to 50 "braccia" (29 meters), thus enjoining the "beheading" of the taller ones, some of which exceeded 70 "braccia". In 1255 construction began on the **Palazzo del Podestà**, whose tower can be seen below between the Badia Fiorentina and Palazzo Vecchio. It became the seat of the Podestà in 1266. The building is now known by the name it came by in 1574, when the role of Captain of Justice, or "Bargello," was instituted.

give up the fight, at the beginning of the 14th century the power struggle approached a conclusion that would be favorable to the city-states. While the imperial institution had lost a great share of its political and military strength, the independent Italian city-states were by then solidly rooted.

The "consular city-state"

Now let us go back for a moment to the political institutions of these city-states. Before long the new civic power came to reside in restricted representative bodies: the consulates. In Florence's case eight consuls were placed to guide the city – two or three per district – collaborating with jurists known as 'causidici.'

Then there was a council with deliberative and consultative powers, consisting of about 100-150 members, most of them not linked to the noble classes. A popular assembly or *arengo* lay at the base, convening quarterly in the convent of Santa Reparata. Its powers included the ratification of the consuls' actions, the approval of treaties and the confirmation of statutes defining the obligations and functions of each governing body.

The civic order described thus far seemingly enjoyed a democratic character, but questions remain. Who were the "citizens," or those who chose the consuls and the members of the council, and that participated in the assembly? We know that not all Florentine residents enjoyed political citizenship. In fact, most of the power remained in the hands of an élite

composed of noblemen and wealthy merchants, who jealously protected their monopoly over culture, and had been affecting various aspects of civic life for centuries.

The arbitration of the "Podestà"

The substantially oligarchic structure of the "consular city-state" gradually entered into crisis, largely owing to the endemic struggles among the patrician households. The noble families dotted the cities with their fortified towers, protected by knights and footsoldiers who emerged only for periodic skirmishes with their rivals. The conflicts were further exasperated by the blend of pride and arrogance typical of chivalrous society.

In the hopes of remedying the chronic state of civil war, an individual executive magistrate was then established: the *podestà*. Selected either by the assembly or by the more restricted bodies, the institution of the podestà was designed to ensure a measure of impartiality in civic government. As it turned out, the podestà, generally originating from the limited number of influential families, wound up exercising his power with blatant partisanship. It was therefore decided that, in order to offer the necessary guarantee of neutrality, the podestà must be an outsider. More-over, the office was regulated by a code of conduct: in Florence, the *Liber de regimine civitatum* ('Book of City Management') is still extant, a sort of 'how-to' for the perfect podestà. Once the appropriate candidate was identified, the government had to first ask authorization from the city to summon him. Once obtained, the candidate was contacted to establish his compensation and the start-date of his tenure. In the case of his acceptance, the magistrate took office with a solemn swearing-in ceremony, performed in the presence of the bishop and the armed citizenry. To avoid being influenced by special interests, the podestà had to limit his contact with the citizens to a minimum: he was even forbidden to dine out. During the course of his year-long tenure, he was flanked by the seven rectors of the Arti Maggiori ('Major Guilds').

In the first half of the 14th century (1337-1339) Ambrogio Lorenzetti explored aspects of civic administration in the pictorial cycle known as **Good and Bad Government** (Siena, Palazzo Pubblico, Sala della Pace). The artist integrates allegorical imagery with realistic scenes depicting the daily life of his time.

Above: **Madonna dei Cordai**, by Donato de' Bardi known as Donatello (1386-1466?). The work was commissioned by the Ropemakers Guild (Florence, Museo Bardini).

The rise of the middle class and popular institutions

The guild phenomenon had an extremely signifi-cant role in Florence's economic and civic life. The Arti were free professional or trade associations, each of them having a captain or *gonfaloniere* ('standard-bearer'), a coat-of-arms and a patron saint. There were seven Major Guilds in Florence: Judges and Lawyers, Cloth Merchants, Bankers and Moneychangers, Wool, Doctors and Apothe-caries, Silk Weavers and Vendors, Furriers and Tanners (the latter tanning the squirrel hides used in the manufacture of military uniforms). There were also fourteen Arti Minori ('Minor Guilds'), among which the Butchers, Cobblers, Blacksmiths, Innkeepers, Locksmiths, Bakers and Winemakers.

The ever-increasing prestige of the guilds attests to the growth – particularly accentuated between the 13th and the 14th century – of the mercantile and artisan bour-geoisie in various Italian cities, notably in Florence. Posing itself as 'the people' the middle class began to demand more say in the city's political life, hoping to check the predominance of the nobility. Thus were born the popular institutions. In Florence the "people" were grouped into twenty companies, each of which represented its neigh-boring citizens. Each company was headed by a gonfaloniere assist-ed by four rectors, all elected by a council consisting of twenty-four representatives, elected in turn by the members of each company. In the event of war the companies were required to form a civilian army: this was a significant innovation as the nobility had maintained a mo-nopoly on warfare throughout the feudal Middle Ages.

There was also an official *capitano* to lead the people. He carried the flag (with one red and one white horizontal stripe) and ordered the ringing of the bell in the Tower of the Leoni, near the Ponte Vecchio, summoning the people together when the city was in peril. The captain also flanked the podestà as defender of civilian rights.

Guelphs and Ghibellines

A certain hostility towards the nobility clearly emerges from the statutes of Florence's popular institutions. A reward was offered to any person revealing the existence of an aristocratic conspiracy that might damage the captain or the people in general. A power dualism emerged in which the middle class and its institutions challenged the ancient order dominated by the nobility, hoping to overthrow it.

Around about the same period (the first half of the 13th century) Frederick II, Emperor of the House of Swabia and King of Italy, waged war against the city-states. They, in turn, adopted a political terminology destined to become famous, dividing into Guelphs and Ghibellines. The Ghibellines were defined as those allied with Frederick, the Guelphs being their adversaries and thus backed by the Pope. The two terms have a Germanic origin: during the reign of Conrad III of Swabia (1137-1152) a great rivalry developed between his own ducal family of Hohenstaufen and that of Bavaria. The supporters of the former were called *Waiblinger* (which, introduced into Italy, became *ghibellini*); those of the second group were known as *Welfen* (in Italian, *guelfi*) from the name of a distant ancestor.

Why did the city-states thus divide themselves rather than uniting in opposition to Frederick? This can largely be explained by the fact that among the various noble families (and among the city-states themselves) old rivalries died hard. In the 1220s, for example, Pisa and Siena went Ghibelline to oppose the Guelph Florence, which was aspiring for hegemony throughout Tuscany. In one particularly fierce

Facing page, below:
Legislation and **Weaving**
(Florence, Museo dell'Opera del Duomo). These tiles by Andrea Pisano (d. 1349) belong to the iconographic cycle of Giotto's Campanile. The cycle represents, on three levels, man's journey toward salvation.
Below: The **Battle of Montaperti** depicted on a 14th-century manuscript (Siena, Biblioteca Comunale). Manfred's German mercenaries left so many corpses in their wake that the local inhabitants were forced to evacuate for fear of epidemic.

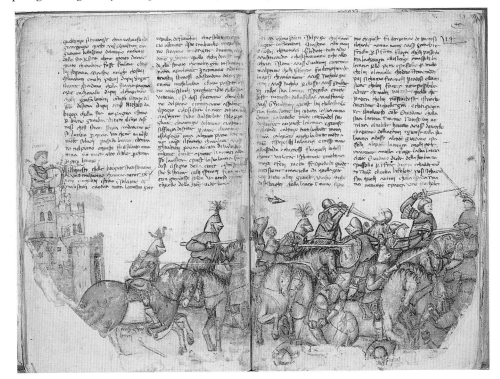

Dante Alighieri, as portrayed by Andrea del Castagno (d. 1457) in a fresco from the Villa Carducci in Legnaia (Florence, Uffizi). Below: The gold "fiorino." First minted in 1252, the Florentine coin became in a few decades the preferred currency in all of Europe (Florence, Bargello). Facing page, above: **Exile of the Duke of Athens** (July 26 1343) in a fresco by Andrea di Cione known as Orcagna (1308?-1368), from the ancient prison of "Le Stinche" (Florence, Palazzo Vecchio).

Facing page, side: The **tower of Palazzo della Signoria** (early 14th century). In order to begin construction Arnolfo di Cambio was forced to demolish a nave of the Church of San Piero a Scheraggio: the Priors wanted no part of their palace to be built on the "Ghibelline soil" formerly belonging to the vanquished Uberti family.

struggle, Florence and Siena fought for control over the Valdelsa, a critical zone for the provision of grain and for the presence of important communication lines.

The birth of these factions further complicated political life. In Florence, there were both Guelphs and Ghibellines, and each of the parties established headquarters (in Florence the Palagio di parte Guelfa still exists), an army and an internal political structure. Their uneasy coexistence ultimately erupted into a conflict that would last throughout the 13th century, ceasing only after the turn of the century. Here we will highlight just a few episodes: in 1260 at Montaperti the Ghibelline armies of Pisa, Siena and Pistoia defeated the Florentine Guelphs, and the Ghibellines dominated the city for the next six years. In 1266 Frederick II's heir, Manfred, was defeated in Benevento by Charles of Anjou (brother of Louis IX of France and allied with the Pope), resulting in yet another political turnover. Three years later the Tuscan Ghibellines suffered a bitter military defeat at Colle Valdelsa.

A new schism emerged towards the end of the century that would render the political struggle in Florence all the more acrid: the Guelph party split into the Neri ('Blacks') and the Bianchi ('Whites'). This division originated from the rivalry between two groups of important families in the city's bourgeoisie: the Donati and the Spini (the Blacks) on the one side, and the Cerchi and their allies (the Whites) on the other. At stake was – as one might imagine – the political leadership of the city. The Blacks were supported by Pope Boniface VIII, while the Whites lacked a similarly authoritative support. As was the case in the struggle between Guelphs and Ghibellines overall, hatred and vendetta were the order of the day. Poet Dante Alighieri, a member of the White faction, was banished from Florence in 1301. He would never again set eyes on his homeland, dying an exile in Ravenna in 1321.

The government of the "Priori"

As early as the first half of the 14th century one could detect a tendency among the Italian city-states that would ultimately lead to the downfall of the democratic order and to the birth of the *signoria* – a form of government based on the exclusive power of a single family and the unquestioned primacy of the *signore*.

However, it is important to note that in Florence's case 'signoria' did not refer to personal power, but rather to the new government born from the bosom of the middle class: that of the eight *priori*, six of which represented the Major Guilds and the remaining two the Minor Guilds. Their names were selected at random from the eligible membership – any guild member, that is, who was at least thirty years old. At first the Priors held office for two months, which were later to become six. They elected a gonfaloniere among themselves, who served a purely representative role.

In running the government the Priors were obligated to consult two other organisms, the Dodici Buonomini ('Twelve Good Men') and the Sedici Gonfalonieri ('Sixteen Gonfalonieri'). Among the other collective magistrates, the Otto di Guardia ('Eight of Surveillance') had the role of secret police, the Sei di Commercio ('Six of Commerce') monitored economic activity. The names of these officers were all drawn by lot. It was also possible to consult the people directly: in times of war, when serious decisions had to be made, all of the male citizens over the age of fourteen were summoned to the Piazza della Signoria by the ringing of the town bell. The consent of two-thirds of the eligible voting population permitted the emergency convocation of the Dieci di Balìa ('Ten of Command'), responsible for organizing military defense and endowed with extraordinary powers.

Towards personal power: the Duke of Athens

The apparatus of the Florentine government had thus grown quite complex. Nevertheless, it was in this very complexity that resided the major guarantees against tyranny: so much so that the republican regime would manage to keep Medicean power in check for nearly a century. As we will see, Cosimo the Elder, Lorenzo the Magnificent and even Duke Alessandro, although the most important and influential citizens in Florence, never held executive office. It was not until 1569, when the Grand Duchy was born under Cosimo I, that the Florentine government would become an hereditary monarchy.

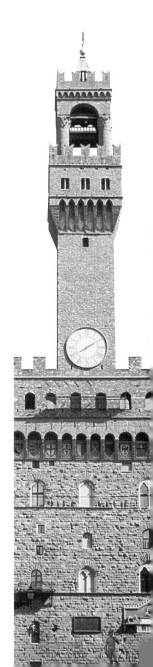

The "Opera del Duomo" (Cathedral Works) was established to oversee the construction of the Cathedral of Santa Maria del Fiore (1296-1378). The institution's patronage, first entrusted to the Major Guilds, was then turned over exclusively to the Wool Guild. Indeed, the Opera shares the Wool Guild's emblem: the **Agnus Dei**, seen to the right (Florence, Museo dell'Opera del Duomo). Below: A portion of Florence's **sixth ring of city walls** (the third Medieval ring), built between 1284 and 1333. The demolition of the preceding ring was necessitated by the remarkable demographic growth that accompanied the city's swift economic development.

Before their collapse, however, the democratic institutions suffered a long period of crisis. The first warning signs came from afar, stemming from Florence's participation in the Guelph alliance against Ghibelline rulers in Northern Italy (including the Visconti in Milan, the della Scala in Verona and Castruccio Castracani in Lucca). The King of Naples Robert of Anjou was a pivotal figure in the Guelph alliance. He managed to convince Florence to accept – albeit *pro tempore* – his signoria, with the ostensible aim of uniting the Guelph military command on Tuscan soil. In reality, he instituted a form of individual government not unlike, for certain aspects, the dictatorship of republican Rome.

In 1325 Robert's regime was followed by the short-lived one of his son Charles, Duke of Calabria, who did not even govern directly but rather by means of his vicars. Upon the Duke's death in 1327, the city reverted to its old order, and the public powers solemnly swore to never again trust any signoria. Vain promises: fifteen years later Florence, hoping to restore its military force compromised by an unfortunate campaign against Lucca, placed itself in the hands of another foreign ruler, the French Walter of Brienne, Duke of Athens and one-time lieutenant-governor to Charles of Valois. On the one hand his ephemeral dictatorship aspired to win popular favor: Walter reinstated many of the traditional festivals that had been abolished, introduced new ones, and moreover sanctioned the creation of the new Arte dell'Agnolo, designed to represent the so-called "little people," or workers in the wool industry. On the other hand, however, he made widespread use of police terrorism to quiet his enemies. As often occurs, violence leads to violence: in 1343 a popular uprising put an end to the brief rule of the French duke.

The Revolt of the Ciompi

In 1378 not long before the Medici's debut on the political and economic scene in Florence, a significant episode known as the 'Revolt of the Ciompi' came to pass. In this period, the political order in Florence had a bipolar structure, composed of:

(a) the official government of the Eight Priors (or the representatives of the Major Guilds), and the Gonfaloniere of Justice. In governing, the Major Guilds clearly held precedence over the Minor ones. Countless small shopkeepers and artisans were excluded from political representation, as were salaried workers (such as those of the Wool Guild, known as Ciompi);

(b) the so-called Parte Guelfa, composed of the civic nobility.

A bitter conflict existed between the latter and the middle class, exacerbated by the war (1375-July 1378) waged by the Florentines against the papal army of Gregory XI, who was intent upon expanding Church territories into Emilia. Disapproving of the anti-papal war, the Guelphs sought to boycott it, "admonishing" the suspects of Ghibellinism. In Florence Ghibellines in the true sense of the word had disappeared some time back; this notwithstanding, the doorway to exile was thrown open to the supporters of the conflict.

The Florentine bourgeoisie reacted to the Guelph attack by renewing the provisions of the *Ordinances of Justice*, developed some eighty years earlier by the 'commoner' Giano della Bella, and later repealed. The order specified that families included on the list of city magnates were automatically excluded from political life. Now, in Florence the word 'magnate' referred to the feudal lords who had arrived from the countryside and moved in around the turn of the century: in other words, the lifeblood of the Guelph coalition. In June 1378 Gonfaloniere of Justice Salvestro de' Medici – a member of the secondary branch of the family – proposed the restoration of the *Ordinances* to the city councils. In response to the councilmembers' opposition, the anti-magnate party urged the people to revolt, winning the Minor Guilds' decisive backing. June 21 was marked by armed conflict and appalling violence, in which the middle and working classes would ultimately prevail. On June 28 a new government was formed, but ap-

15th-century "cassone" attributed to Rossello di Jacopo Franchi (Florence, Bargello). The chest depicts the horse races run annually on June 24 in honor of St. John the Baptist, Florence's patron saint. During the grand-ducal era the ceremony was moved to Piazza della Signoria. The Baptistery, seen on the left, is one of Florence's most ancient structures: dating back to the 5th century, it assumed its current appearance between the 11th and the 13th century. Its octagonal shape symbolizes the sacrament of baptism, which initiates the new life in Christ on the "eighth day," the first seven days representing mortal time. In the 11th century, during construction on Santa Reparata, the Baptistery also served the function of cathedral.

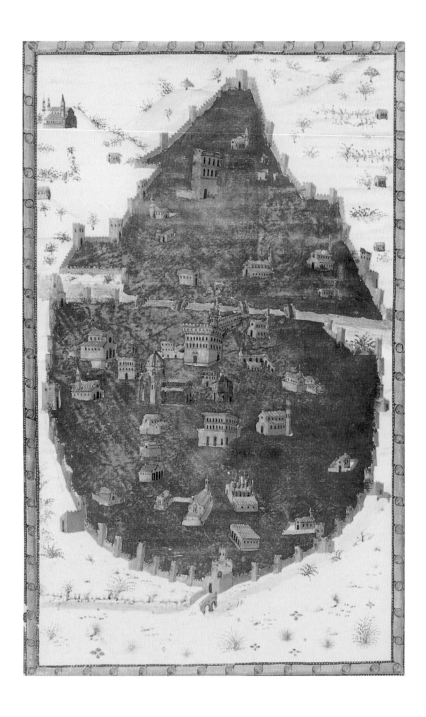

peared unwilling to back the radical innovations forwarded by the Minor Guilds and the working classes. The popular bloc of the anti-magnate front consequently decided to organize another uprising, but the conspirators were taken under arrest. The arrests led to another day of violence; and on July 21 the rebels eventually overcame, imposing the creation of three new Minor Guilds, each of which reserving a post in civil government. Michele di Lando, representing the ciompi, was named Gonfaloniere of Justice.

The new political order was boycotted by the great merchants, who closed their factory doors, bringing unemployment and hunger to the workers. The latter attempted to fight back by proposing even more radical innovations that presupposed their direct participation in city government, but were abandoned by the Minor Guilds and the new Gonfaloniere of Justice. It would be this very same "traitor," Michele di Lando, who led the ciompi into a trap: on August 31 the demonstrators were massacred in Piazza della Signoria, all of its exits having been duly sealed. Four years later all Minor Guilds were suppressed.

The popular cause's sorry end bore a precise political significance: the great mercantile and financial middle class now held hegemony over the city, and from its ranks would soon arise the family destined to rule Florence.

Below: **Healing of the Lame and the Resurrection of Tabitha,** by Tommaso di Cristoforo Fini known as Masolino da Panicale (1383-1440?). The biblical scenes unfold against a backdrop that reproduces in idealized form a 15th-century Florentine "piazza" (Florence, Santa Maria del Carmine, Brancacci Chapel).

Facing page: **Map of the city** from a 15th-century codex. The image emphasizes the structure of the ring walls and the main buildings of Florence (Rome, Vatican Library).

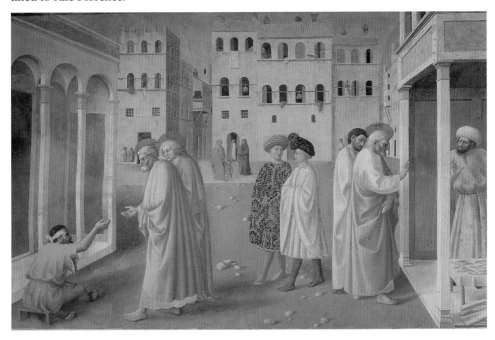

The dawn of power

During the 12th and 13th centuries the renewed splendor of urban life in Florence – and its accompanying economic promise – lured many people, nobility and peasant stock alike, from the surrounding countryside. Among those who arrived seeking fortune in the city were the Medici, an obscure family from the Mugello.

The disputable origins of the family name

The Medici originated in rural Mugello, some thirty miles north-east of Florence. Moving to the city in the late 13th century, they abandoned agriculture to dedicate themselves to commercial activity.

What are the origins of their family name? According to one theory later discarded as legendary, they were called "Medici" because one of their ancestors was a doctor (or *medico*); the six red balls on a field of gold portrayed on their family coat-of-arms might represent pharmaceutical pills. In fact, there is no proof to substantiate that in the past any of the Medici were actually *medici*.

Others claim that the spheres on the coat-of-arms represent *bisanti*. The bisante was a weight of Byzantine origin (hence the name), used by medieval merchants and bankers to check their coins.

Giovanni di Bicci

The first Medici to amass a real fortune was Giovanni, the son of Averardo known as Bicci and great-grandson to another Averardo, who had served as Gonfaloniere in the 14th century. Giovanni's children sired the two historical branches of the family. The first branch (that of Cosimo the Elder, grandfather to Lorenzo the Magnificent) died out at the end of the 16th century, while the secondary branch (that of Lorenzo the Elder) would survive through the first half of the 18th century.

Giovanni was first of all a businessman, proprietor of a bank with branches in Italy and throughout Europe: France, England, Germany, the Netherlands. His influence over Florentine public life was largely indirect. Patron and friend to the powerful, he hosted the disgraced an-

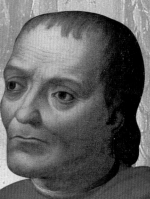

Giovanni de' Medici, son of Averardo (known as Bicci) and Giacoma degli Spini. Giovanni was married to Piccarda Bueri (known as Nannina), and together they brought Cosimo and Lorenzo into the world. The portrait, a 16th-century work by the school of Bronzino, is one of a series representing the principal members of the family (Florence, Uffizi).

Madonna and Child enthroned with Angels and Saints (Florence, Museo di San Marco), by Giovanni da Fiesole known as Beato Angelico (d. 1455). The splendid altarpiece was commissioned by Cosimo the Elder around 1450, when the Medici financed the reconstruction of the Mugellan Convent of San Bonaventura di Bosco ai Frati. The composition features the family's patron saints, Cosmas and Damian. Below: Exterior of the **Basilica of San Lorenzo**. Consecrated in 393 by Ambrose, Bishop of Milan, the church served as Florence's cathedral until the 8th century. Renovated in Romanesque style and reconsecrated in 1059, it was entirely rebuilt in the first half of the 15th century on the Medici's initiative. The project was entrusted to Filippo Brunelleschi (1377-1446) who was at the time designing the dome of the Cathedral. The façade of San Lorenzo remains "al grezzo," or undecorated, as none of the proposed designs (including one by Michelangelo) was ever implemented.

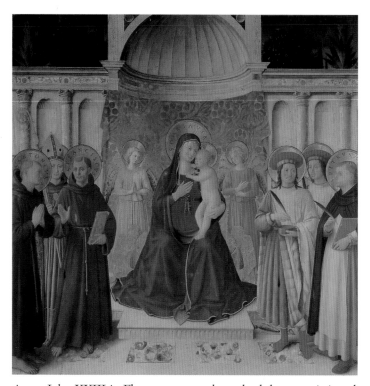

tipope John XXIII in Florence, upon whose death he commissioned Donatello and Michelozzo for a funeral monument inside the Baptistery of San Giovanni. The first forty years of Giovanni's life were dedicated exclusively to the administration of his affairs: it was only at the beginning of the 15th century that he began to involve himself in city politics. In 1402 he was elected prior of the Bankers and Moneychangers Guild and would be re-elected to the post in 1408 and 1411. He confirmed his reputation as a generous man in his aid to the citizens in 1417, when Florence was struck by a terrible plague epidemic that would reap 17,000 victims.

In spite of this catastrophe Florence was a thriving city, full of artistic initiative. In 1401 a competition was announced for the Baptistery doors: it would be won by a very young Ghi-

berti, who triumphed over contenders as distinguished as Filippo Brunelleschi and Jacopo della Quercia. In these same years the palace of Orsanmichele was remodeled with funds from the Wool Guild, and decorated on the outside with the patron saints of the various guilds, sculpted by the foremost artists of the time.

Giovanni himself offered a significant contribution to the betterment of his city. Protagonist and patron to his most beloved neighborhood (situated between the Duomo and the Porta a San Gallo), he financed the foundation of the charitable Spedale degli Innocenti ('Foundling's Hospital') in 1419. Filippo Brunelleschi dedicated almost seven years of work to the edifice, drawing it to a finish in 1425. In this same period Michelozzo superintended the expansion of the Church of Santissima Annunziata. The wealthy banker had a marked predilection for Brunelleschi's architecture, inspired by the new principles of symmetry, harmony and proportion. Not coincidentally, he picked out the designer of the dome for the renovation of San Lorenzo's ancient Basilica, at the time literally falling into ruin.

By the time that death claimed him in 1428, sixty-eight-year-old Giovanni had succeeded in quieting the malicious rumors that formerly circulated regarding the Medici, fostered by their rivals in finance and commerce: their reputation as a coarse and unscrupulous people, vulgar *nouveau riches* animated only by the logic of profit and personal interest. The credit accrued by his image as a generous and visionary man would constitute the solid base from which would grow the future fortunes of the dynasty.

Cosimo the Elder's marriage

Born in 1389, Cosimo lived his first forty years in the shadow of his father Giovanni, during the *de facto* dictatorship of the Albizzi family by whom he would be exiled. At the age of twenty-five he married a woman of good standing: Contessina de' Bardi. Up until a short time before the Bardi had been the wealthiest family in Florence and the bankers of Europe. Then the fortune of these princes of finance melted like snow in the sun.

The **Medici coat-of-arms** decorates the façade of the family's palace on via Larga, known today as the Palazzo Medici-Riccardi. According to one legend concerning the insignia's origin Averardo de' Medici once battled against a giant in the Mugello, whose mace left him with six spots of blood on his shield. Below: The so-called "**Adimari Cassone**" (Florence, Accademia), a 15th-century piece attributed to Giovanni di ser Giovanni known as Scheggia (1406-1486). Such chests were given to young brides to store their dowry: not coincidentally, a wedding procession is depicted against the standard backdrop of Piazza San Giovanni.

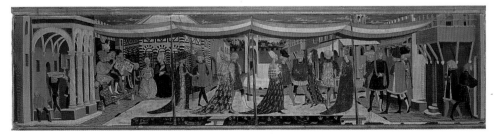

The Bardi's ruin was related to international events. In order to finance the interminable war against the French, having for some time sapped the coffers of the British state, King Edward III requested from the Bardi and the Peruzzi (another great Florentine banking family) a loan so enormous that, as wrote historian Giovanni Villani, "it was worth a kingdom." The Bardi and the Peruzzi trusted him: what better guarantee than that of a Very Christian King? In Florence, it's true, the usual naysayers circulated an ironic, pessimistic ditty – "The King of England won't pay" – but who could believe this sort of prophecy? And instead, Edward, exasperated by the lackluster results of the conflict, defaulted on his loan. The Bardi banks were devastated and the Peruzzi practically bankrupt; many solid Florentine merchants, who had backed the loan as the deal of the century, cried bitter tears.

The frescoed equestrian monument of **Giovanni Acuto**, by Paolo Uccello (Paolo di Dono known as, 1397-1475), detail (Florence, Santa Maria del Fiore). Having fought in the Hundred Years' War under the banner of Edward III, mercenary captain John Hawkwood served the Signoria from 1377 until his death in 1394.
Below: Giovanni Stradano (Jan van der Straet, 1523-1605), **Old Market**, detail (Florence, Palazzo Vecchio, Quartiere di Eleonora, Sala di Gualdrada). Before construction began on the luxurious palace on Via Larga, the Medici family homes were located in this working-class district in the heart of Florence. When the city became the capital of Italy (1865-1870) the neighborhood was razed to the ground, making way for today's Piazza della Repubblica.

Cosimo's marriage to Contessina was not, therefore, one of economic interest: while the young woman conserved the dignity and splendor of her name, she offered little else by way of dowry. Anyway Cosimo was not hurting financially. The Medici bought Palazzo Bardi, and Cosimo and Contessina lived there until Giovanni's death. Their first-born Piero (later know as "the Gouty") was born there in 1416.

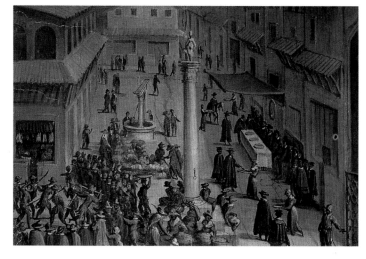

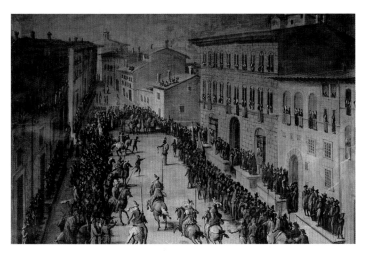

Giovanni Stradano, **Saracino Joust in Via Larga** (Florence, Palazzo Vecchio, Quartiere di Eleonora, Sala di Gualdrada). By the time this piece was painted, the external "loggia" of the family palace (the imposing building to the right) had already been sealed off for security reasons. In 1670 the palace was purchased by the noble Riccardi family, who proceeded to expand it by renovating the adjacent building. Below: The celebrated bronze **David** that Donatello sculpted for Cosimo the Elder in 1430, not long before the Medici was exiled. (Florence, Bargello).

The palace on Via Larga

Cosimo, nevertheless, wanted to live in a mansion of his own, and one worthy of his newly-gained prestige. Towards this end he summoned Brunelleschi: notwithstanding his many other commitments (among which the basilica of San Lorenzo), the architect found the time to draw out a plan. When it was presented to him, however, Cosimo was taken aback. The design was so grandiose that, were it carried out, the Florentine aristocracy would take it as a sign of intolerable arrogance. The commoners, for their part, would interpret it as a resounding slap in the face of wide-spread poverty. It was excessive even by Cosimo's ambitious standards, and he decided against the construction of the colossal structure. Considerably more modest, although equally innovative, was the design of young Michelozzo Michelozzi, and construction was promptly under way. But even this palace (much smaller in its original form than the one we see today) would be condemned as pretentious by the Florentine nobility backing Rinaldo degli Albizzi's hegemony. Perceiving the Medici's growing prestige and popularity among the people, they set out to find a pretext for banishing them from Florence.

A period of exile

The most authoritative and influential aristocrat, Niccolò da Uzzano, declared his opposition to the exile provision. Upon his death in 1432, however, the extremist Albizzi par-

ty had free rein, intensifying the campaign of allegations against the Medici (accused of trying to elevate themselves above the level of common citizens). Little time passed before Cosimo found himself in prison. Fearing for his life, as poison was freely administered in this epoch, he refused the food offered by his jailers. He asked – and was granted – permission to receive his meals from home. Officially, any communication with the outside would have been prohibited, but prison guard Federico Malavolti displayed a leniency with his prisoner surely not unrelated to cash. Perhaps this very money also nourished the growth of popular support for the Medici, compelling the government to commute the jail sentence into one of exile. At any rate the family had to abandon the controversial palace. Cosimo moved first to Padua and then, in 1433, to Venice, where his brother Lorenzo had already taken refuge.

Donatello created this bust of **Niccolò da Uzzano** in polychrome terracotta. Cosimo's defender is represented in the garb of a Roman orator; in his expression the artist has managed to blend pride with a subtle, superior irony (Florence, Bargello). Below: In one of the cells reserved for Cosimo in the Convent of San Marco, Beato Angelico and Benozzo Gozzoli (1420-1497) painted an **Adoration of the Magi** in which one can recognize the influence of the Council.

The triumphant homecoming

The moment had arrived, however, for an upheaval in Florentine politics. In the brief course of a year the Albizzi dictatorship fell into crisis, and the city authorities summoned Cosimo back to Florence. The city, as Machiavelli recalls, welcomed him home with all honors: "Rarely has it occurred that a citizen, returning triumphant from a victory, was received by the fatherland with such a gathering of people and with such an outpouring of benevolence."

Confirming his reputation for prudence and equilibrium, Cosimo did not take advantage of the great power now at his disposal. Not even the decree banishing the Albizzi family and their closest supporters from Florence was directly his work, but rather that of the Signoria, anxious to protect itself from the continual pressures of a political party grown manifestly unpopular.

From that moment on Cosimo adopted the role of mediator in Florentine politics. Maneuvering with skill, working with great discretion behind the scenes, he succeeded in winning the favor of the rank-and-file as well as that of the upper middle class. His was not a dictatorship: although subject to certain conditions, the republican institutions remained intact. Cosimo earned

prestige and success at the international level as well: he managed to change from Ferrara to Florence the location for the Council called by Pope Eugene IV in his attempt to reconcile the Roman Catholic and Greek Orthodox churches. The Patriarch of Constantinople arrived to a warm welcome, and the entire duration of the Council was marked by spectacular festivities, dances and shows.

Relations with Milan and Venice

Cosimo's foreign policy was ambitious but problematic. Traditionally Florence was allied with Venice against the Duchy of Milan, ruled by Filippo Maria Visconti. The latter aspired to extend his reign southwards, beginning with Tuscany itself. He did in fact launch the enterprise, but in 1440 the Florentine army subjected him to a bitter defeat at Anghiari, near Arezzo. Cosimo then contacted Francesco Sforza, an able and astute commander of mercenary troops and husband to Bianca Visconti, daughter of Filippo Maria. Filippo Maria had promised to leave the duchy in inheritance to Sforza; but when his will was opened in 1447, it was discovered that he had designated Alfonso of Aragon, King of Naples, as his successor. Sforza decried the betrayal and prepared his army to march on Milan, which in the meantime had declared itself a republic. At this point Cosimo decided to give Francesco a hand, bestowing a generous financial backing that allowed the commander, after a long struggle, to subdue the bitter resistance of the Milanese. Predictably, Cosimo's decision provoked not only the wrath of Venice and Naples, but also the criticism of many Florentines who considered it profoundly immoral to support an anti-republican like Sforza. He countered the accusations with the same logic of political realism that would so successfully inspire his grandson Lorenzo: the alliance with Venice couldn't last long in any case, as the interests of the *Serenissima* ("Most Serene Republic") were in conflict with those of Florence, especially in regards to the Mediterranean. Milan, on the other hand, could prove a good ally, as it was not in direct competition with Florence at the commercial level. Moreover, peace with the powerful duchy could indirectly represent the key to the pacification of the entire peninsula. Anyway, Venice and the Kingdom of Naples struck an alliance and declared war on Florence, which in turn secured the protection of Charles VII of France. The two fronts were stalemated on the battlefield, and in 1454 a peace treaty was signed in Lodi.

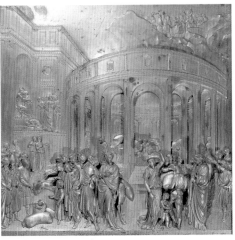

Stories of Joseph, by Lorenzo Ghiberti (1378-1455), from the Baptistery's Gates of Paradise. The scenes contain veiled allusions to Cosimo's efforts to reconcile the Greek Church with the papacy.
Below: In the Chapel of the Magi in Palazzo Medici-Riccardi Benozzo Gozzoli depicts the **Patriarch of Constantinople**. The Council fostered the proliferation of the oriental motifs originally introduced in Medicean iconography by the Platonic Academy.

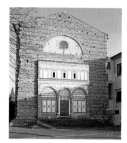

Above: The Romanesque façade of the **Badia Fiesolana**, framed by the larger Renaissance one. Possibly designed by Cosimo himself, the work was left incomplete at the time his death (1464).
Below: Luca della Robbia (1399?-1482), **Choir Gallery**. Inspired by Psalm 150, the work conveys with truly classical sensibility the emotions that permeate the young musicians (Florence, Museo dell'Opera del Duomo).
Facing page, left: **The Holy Trinity and St. Jerome with St. Paula and St. Eustochiò**, frescoed in 1454 by Andrea del Castagno (Florence, Church of Santissima Annunziata, third chapel).

Cosimo the Elder and culture

Some have characterized Cosimo as a man lacking culture, but this image seems clearly contradicted by the artists that he supported and with whom he surrounded himself. Under Cosimo Florence enjoyed a season unlike any before or since, one workshop opening after another. All of the great painters and architects of the day were feverishly at work. The palace on Via Larga yet to be completed, Michelozzo was already redesigning the small monastery of San Marco (where Cosimo reserved two cells for himself in which to reflect in moments of intense political pressure). Luca della Robbia, Fra Giovanni Angelico, Andrea del Castagno, Paolo Uccello and Domenico Veneziano all worked for him.

Cosimo was keenly interested in the cultural and artistic development of the city, so much so that in 1444 he founded the first public library in Europe, anticipating the Vatican by some thirty years. The Medici library was first housed in the palace on Via Larga, and then moved to its permanent address, designed and built by Michelangelo next to the basilica of San Lorenzo. Extremely rich from its inception, the collection includes an original copy of Justinian's *Pandects* and manuscripts of works by Cicero, Tacitus, Virgil, Pliny the Elder, Dante and Petrarch, as well as many Florentine works from the 13th and 14th centuries. This very library would undergo a paradoxical interlude: after having founded it with an outpouring of energy and funds, the Medici would see it confiscated at the time of their second exile (1494). In order to regain it, they would be forced to buy it back. The job fell to Giovanni, son of Lorenzo the

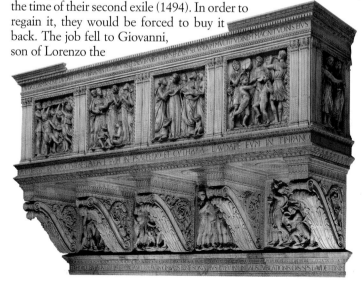

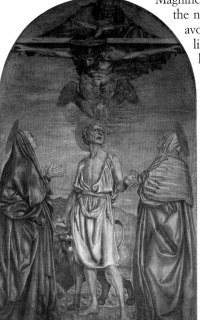

Magnificent, ordained as pope with the name of Leo X. In order to avoid risks he moved the entire library to Rome; only upon his death another Medici, Pope Clement VII, brought it back to Florence, where meanwhile had risen the edifice destined to house it.

For the first time in Florentine history Cosimo the Elder created a sort of court life, whose protagonists were mostly men of culture and artists: Donatello, Brunelleschi, Politian (poet Agnolo Poliziano), Vespasiano da Bisticci, Pico della Mirandola and countless others.

Family politics. Death of Cosimo

Above: **Villa of Careggi**, where Cosimo the Elder breathed his last. Purchased by Lorenzo the Elder in 1417, the residence was restructured by Cosimo, who employed the services of Michelozzo (1396-1472), and by Lorenzo the Magnificent, who called upon Giuliano da Sangallo (1452-1516) to make further modifications. It was seriously damaged by fire after the flight of Piero the Unfortunate. Below: **Cosimo the Elder** in a portrait by the school of Agnolo Bronzino (Florence, Uffizi).

Careful in his political decisions and business affairs, Cosimo proved to be shrewd and fortunate in his private life as well. Contessina de' Bardi was an outstanding wife, completely absorbed in the care of the household and of her two sons, Piero (b. 1416) and Giovanni (b. 1421). To facilitate their success – be it in the political or financial arena – Cosimo sought to endow them with the finest education of the time.

At first the results weren't exactly those he had anticipated: his sons failed to demonstrate any particular brilliance. Piero was of delicate health, plagued from infancy with rheumatic fevers; Giovanni, indolent and epicurean, seemed more interested in a life made up of cultural and earthly pleasures – fine arts and pretty young women – than in business and politics. His son's lifestyle drove Cosimo to desperation; moreover, Giovanni preceded his father to the tomb by a year (1463). Notwithstanding the suffering that his child had caused him in life, the grief upon his death was even greater. Cosimo lived out his last year in the sad anticipation of a predicted and perhaps desired end, even if to comfort him there was the lively, affectionate presence of Lorenzo – son to Piero and Lucrezia – who would pick up from his grandfather the art of governing and of life.

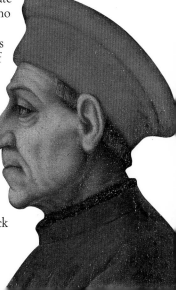

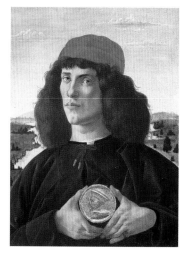

Right: **Portrait of a Young Man**, by Sandro Botticelli (1445-1510). The youth holds a medallion etched with Cosimo the Elder's profile, and the words "Cosmus Pater Patriae" (Father of the Fatherland). This honorary title was bestowed on Cosimo "post mortem" in a decree issued by the Florentine Republic. Below, left: **Giovanni**, Cosimo's beloved son, in a portrait by the school of Agnolo Bronzino. Giovanni's marriage to Ginevra degli Alessandri brought forth a son, Cosimino, who died at the tender age of five. Below, right: **Carlo de' Medici**, by Andrea Mantegna (1431-1506). Cosimo's illegitimate son Carlo was born in 1428 to a Circassian slave bought in Venice. Destined to the cardinal's purple, he was canon of Santa Maria del Fiore and provost in the Cathedral of Prato. Mantegna painted the portrait in 1466, during a mission for Ludovico Gonzaga (Florence, Uffizi).

On August 1 1464 the "Father of the Fatherland" expired in his beloved villa of Careggi, the very location that would witness, some thirty years later, the end of the Magnificent. His last wishes, precise as his life had been, precluded a State funeral: he was honored instead by a long procession leading from Careggi to the Basilica of San Lorenzo. In this church, destined to become the Medici "family chapel," the man who was deservedly considered the first *signore* of Florence was buried with high honors. The following inscription is engraved on the tombstone, that testifies to the love and esteem that the Florentines nurtured for the defunct: "Cosmus Medices hic situs est decreto publico pater patriae" ('Here lies buried Cosimo of the Medici, by public decree dubbed Father of the Fatherland').

Cosimo's troublesome legacy. Piero the Gouty

When Cosimo died, Piero was no longer a young man, and he showed every one of his forty-eight years. Like his father he suffered from gout – although in a form much more painful and violent, so much so that history would remember him as 'the Gouty.' And like his father he was fortunate in his choice of a wife. Daughter of a noble Florentine family with long-standing ties to the Medici, Lucrezia Tornabuoni was a wise and faithful partner. Lover of literature and the arts, she often joined her husband in the role of patron. She bore five children to Piero: Lorenzo, Giuliano, Maria (who married Leonetto de' Rossi), Bianca (future wife of Gugliemo de' Pazzi), and Lucrezia (known as Nannina and married to Bernardo Rucellai).

Piero inherited an extremely challenging political legacy from his father. In his five brief years of governance (1464-1469), he would have to weather more than one storm, yet managed to prevail in a rather splendid manner.

Conspiracy and warfare

To begin with, there was the reaction of the anti-Medicean Florence to his father's years of uncontested power. The city split into two factions, the opposition being led by Luca Pitti – a great merchant who, working with Brunelleschi on the design for his mansion, requested that the windows be as large as the door to his rivals' palace on Via Larga.

Piero, for his part, followed a line of conduct somewhere between republicanism and princedom, respecting representative institutions while at the same time wielding personal power. But even from the grave Cosimo continued to condition his behavior, and in a manner that threatened to prove lethal for his son. Having judged Piero as insufficiently tempered to endure the thorny trials of political life, he had appointed one of his closest friends, Diotisalvi Neroni, as advisor. But just two years after Cosimo's death Neroni joined forces with an anti-Medicean conspiracy ordered by the same Luca Pitti and by Agnolo Acciaiuoli.

The assassination was scheduled to take place on August 26 1466, during one of Piero's frequent commutes from the suburban villa of Careggi – his preferred summer residence – to the city center. But the conspirators were betrayed, and Piero had time to change his plans. Far from finding him alone and defenseless, the assassins were met by an armed battalion headed by his son Lorenzo, and were forced to flee. The assassination attempt could not help but provoke a prompt reaction.

Left: **Piero the Gouty** is identifiable in the procession depicted in the Chapel of the Magi. His personal emblem, a diamond ring bearing the Latin motto "semper" (always), is visible on the horses' harnesses and servants' livery. Piero's son, Lorenzo, used instead the branch of an evergreen tree, along with the inscription "semper virens," as his personal trademark. Below: On the walls of the **Tornabuoni Chapel** in the Basilica of Santa Maria Novella Domenico Bigordi known as Ghirlandaio (1449-1494), represented numerous members of the patron family. Lucrezia is the second figure to the right, although by the time of the painting she had been dead for some years.

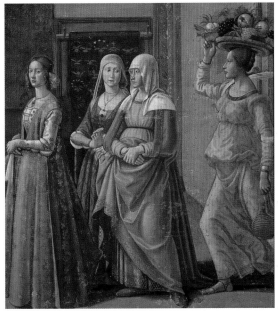

This splendid bas-relief by Michelangelo (1475-1564), known as the **Tondo Pitti**, is named after the family that commissioned it for their private worship. The roundel was completed between 1504 and 1508 (Florence, Bargello).

Using the failed coup as a pretext, Piero rigged the election of a government patently biased in his favor. The conspirators fled before being struck by the hand of justice and would be compelled to pass the rest of their lives in exile. Luca Pitti was the only conspirator to remain in Florence: he confronted Piero's wrath and obtained his pardon. With feigned magnanimity Piero did not impose the death penalty that seemed inevitable; instead, he devised a much more subtle vendetta, inspired by the Dantesque law of retaliation. Pitti, notoriously ambitious and proud of his wealth, was made the object of ruthless commercial warfare, which would eventually bring him and his family to ruin. Work on the grandiose palace started by Brunelleschi in 1440 would remain suspended for more than a century, until in 1549 Buonaccorso Pitti surrendered the still-incomplete edifice to Eleonora de Toledo. She, along with her husband Cosimo I, would transform it into the family's royal palace.

Having stood up to the internal threats, Piero now had to confront a dangerous conflict with Venice. The Serenissima, who had hosted the exiled Cosimo and his family just ten years earlier, was now proudly anti-Medicean, still nursing a grudge against the family for having backed Francesco Sforza. War broke out in 1467. The Venetian troops led by famous condottiere Bartolomeo Colleoni headed south, but thanks to reinforcements from the Duchy of Milan and the Kingdom of Naples the Florentines managed to defeat them severely at Imola.

Just two years after this success Piero, extremely fatigued and worn out by the labors of ruling, was struck by cerebral hemorrhage and died a few days later at the beginning of December 1469. He was honored with a solemn funeral ceremony, but was not granted the honor which had been conceded to Cosimo; the honor, that is, of burial in the Basilica of San Lorenzo. He was buried instead in the Sacristy near his brother Giovanni. The sepulchral monument, commissioned by his sons Lorenzo and Giuliano, is the work of Andrea del Verrocchio.

Florence's growing prestige

In a twist of fate, Piero's brief stint in power concluded during its first tranquil year. Internal conflicts and external threats seemed definitively put to rest. Florence was growing in population and prestige, and its fame was spreading throughout all of Europe. And of course the artistic and intellectual fervor of Cosimo's epoch lived on as sprightly as ever.

It was during the five years of the Gouty's rule that a young and promising painter began to distinguish himself. His name was Alessandro di Mariano Filipepi, better known as Sandro Botticelli. Piero loved him like a son and admired him greatly, and many of the artist's masterpieces were commissioned for the Medici family and their supporters.

The *Adoration of the Magi*, for example, was commissioned by a Medici supporter for his tomb in the Church of Santa Maria Novella. In it the artist celebrates the memory of his powerful Medici patrons, depicting them in the elaborate garb of the three Magi. Cosimo the Elder is at the center of the painting, embracing the feet of baby Jesus. Piero, wrapped in an ornate scarlet mantle, kneels at the side of his brother Giovanni, who wears a white tunic. The young, bareheaded Lorenzo – Piero the Gouty's first-born – is portrayed in a suit of armor like the one he wore to confront the conspirators who threatened his father's life.

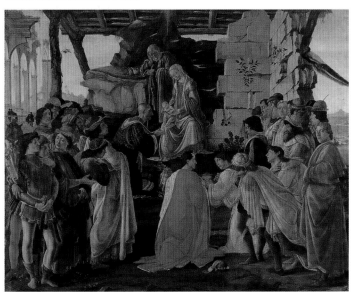

Adoration of the Magi, by Sandro Botticelli (Florence, Uffizi). In addition to the artist's self-portrait (to the extreme right) Vasari identified the faces of Cosimo, Piero and Giovanni. Less certain is the identity of the other figures, among which many have recognized Lorenzo, Giuliano, Politian and Pico. The panel was commissioned by Medici supporter Guasparre del Lama, and intended for his tomb in the Church of Santa Maria Novella. The private celebration drafted by Benozzo Gozzoli in the Chapel of the Magi was thus complemented by the public tribute of a painter who was shortly to attain international recognition.

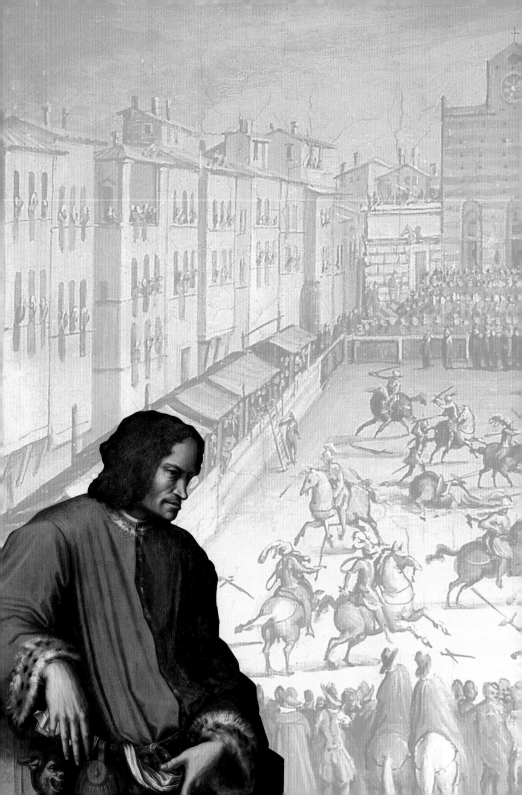

The Magnificent epoch

Upon his return from exile Cosimo the Elder 'Pater Patriae' was widely embraced as the First Citizen of Florence. Following the death of Piero the Gouty, it was Cosimo's grandson Lorenzo who carried on the family tradition. Lorenzo inherited not only his grandfather's love of the arts and literature, but his political wisdom as well. These qualities would earn Lorenzo the title of "Magnificent", by which he would be deservedly remembered.

A rich and complex personality

With Piero's son Lorenzo, the Medici won definitive consecration as the city's First Family, wielding a political power that by now superseded legitimacy within the framework of a republic. During the course of his twenty-three years at the helm (1469-1492), the groundwork was laid for the birth of a regional state.

Under the guidance of this accomplished scholar and statesman – whose complex, multifaceted personality would earn him the title of "Magnificent" – Florence became the universal capital of culture and the arts. Thanks to the circle of intellectuals and artists living in the Magnificent's court, Humanism and the Renaissance spread from Florence throughout Europe, giving birth to a movement of ideas destined to influence history profoundly for two centuries to come.

Though inherited from both of his parents, Lorenzo's love for the arts was even more intense. The youngster also cultivated philosophical interests: it was not by chance that he became friend and protector to Neoplatonic thinker Marsilio Ficino. Although the Medici remained active in finance and trade, Lorenzo's refined upbringing appeared more that of a prince than that of an exponent of the 'fat bourgeoisie.' Moreover, this privileged education was superimposed on a very cunning and versatile personality. Although sharing his uncle Giovanni's hedonistic nature, the Magnificent appeared forever cold, resolute and indefatigable when political circumstances called him to action. His behavior in the face of the conspiracy launched against his father was only the first indication of a remarkable ability, an admirable blend of prudence and courage. There was one gift, however, that Lorenzo lacked – a gift that his

Facing page, below:
Lorenzo the Magnificent, by Giorgio Vasari (1511-1574). The inscription at the base of this idealized portrait reads "Virtutum omnium vas" (vase of every virtue). The painting is now in the Uffizi Gallery.

grandfather had possessed in abundance: business sense, the understanding that the family's strength lay in commerce and financial activity, and that political responsibilities must never distract a Medici from this primary commitment.

Lorenzo, in contrast, was no businessman, but rather an intellectual and a politician, preferring to turn the administration of his affairs over to a handful of trustees. He was the first Medici to spend rather than accumulate, and his would be truly huge expenditures: in his hands the enormous fortune amassed by Giovanni di Bicci and Cosimo the Elder began to dwindle. His successors, who ultimately abandoned finance and commerce altogether, would merely "perfect" the work he had initiated.

A foreigner enters the household

As first-born son, Lorenzo (born in 1449), assumed leadership of the family at the age of twenty. That same year he married Clarice Orsini, a member of one of the most illustrious families in the Roman aristocracy. The bride was chosen by Lucrezia Tornabuoni, who traveled personally to Rome in search of a worthy match among the city's nobility – a match that, as well as furnishing a rich dowry, would forge an alliance that could prove useful in the future. However, not all of the Florentines welcomed her choice, as it was not customary for citizens to search abroad in match-making: consequently, the marriage would be judged by many as akin to betrayal. Nevertheless, Piero and Lucrezia realized that this was the surest way to avoid offending the representatives of the Florentine nobility, all of them eager to marry off their daughters to Lorenzo. The selection of one among many distinguished young women would necessarily exclude the others, inevitably resulting in envy and antagonism. As an outsider, Clarice Orsini was beyond the fray, and at the same time guaranteed a precious alliance with the Papal State.

To make peace with the disappointed Florentines, however, Lorenzo arranged for a tournament to be held in the Piazza of Santa

Above: Among the figures represented in the **Miracle of the Sacrament** by Cosimo Rosselli (1439-1507) one can recognize, from left to right: philosophers Marsilio Ficino and Giovanni Pico della Mirandola, as well as Politian, Lucrezia Tornabuoni's favorite poet (Florence, Church of Sant'Ambrogio).
Right: In the **Vocation of St. Peter** (Vatican, Sistine Chapel) Ghirlandaio depicts Florentine nobility in Rome, including Argyropoulos and Lucrezia's brother, treasurer to Pope Sixtus IV and husband to Francesca di Luca Pitti.

Croce on February 7 1469, a couple of months before the wedding. For the occasion the young Medici did not don the colors of his Roman fiancée, but rather those of the Florentine Lucrezia Donati, elected Queen of the Joust. In his mantle of white silk bordered with scarlet, velvet surcoat and a silk scarf richly embroidered with roses and, above, the French motto *Le tems revient* ('Time returns') interwoven with pearls, Lorenzo was undoubtedly the most gallant knight, although certainly not the most attractive. He was a relatively short man with an olive complexion, his profile deformed by a long, crooked nose that made him resemble a faun. But he won the tournament and the grandiose spectacle, as described by Luigi Pulci (author of the mock-heroic poem *Il Morgante*) in *The Joust of Lorenzo*, would long remain in Florentine memory – as would the memories of the wedding between Lorenzo and Clarice, which was preceded by three full days of dances, games and interminable banquets.

In keeping with the customs of the time Lorenzo's wife was quite young: just seventeen years old. The Magnificent's mother glimpsed the girl for the first time in the neighborhood of St. Peter's and remained quite favorably impressed: Clarice was wearing a plain, high-cut dress, but she was undeniably good-looking, with long, delicate hands. Moreover, from her carriage and gestures she appeared gentle and well-mannered, shy and taciturn. After the marriage, alas, certain characteristics and defects emerged that would undermine her relationship with her bright and sensual hus-

Below: Giovanni Stradano, **Joust of the Knights in Santa Croce** (Florence, Palazzo Vecchio, Quartiere di Eleonora, Sala di Gualdrada), depicting the tournament of 1475. In this painting the church's façade is still undecorated, as it was bound to remain until the mid-19th century. The bell-tower is also missing, limited at the time to the foundations laid by Francesco da Sangallo. To the right can be seen the entrance to the first cloister and to the Pazzi Chapel Left: **Hercules and Antaeus**, by Antonio di Jacopo Benci known as Pollaiolo (ca. 1431-1498). Piero the Gouty commissioned the bronze for the Via Larga palace and placed it in the room of his sons, Lorenzo and Giuliano (Florence, Bargello).

Right: **Madonna and Child with Saints** (Florence, Uffizi), by Alessio Baldovinetti (1425?-1499). Once decorating the chapel of the Cafaggiolo Villa, the work was ordered to celebrate the birth of Giuliano. Below: **Giuliano**, son of Piero the Gouty and brother of Lorenzo the Magnificent, detail from a portrait by the school of Bronzino (Florence, Uffizi).

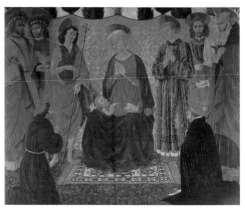

band. Clarice's limited culture, priggishness (typical of the Roman aristocracy), and above all her dull disposition would exclude her from the conversations of Lorenzo and his friends, full of the biting wit and ribald humor typical of Florentine parlor. The marriage, however, endured: aside from the periodic squabble, Clarice would be a boring but loyal wife, faithful to her matrimonial duties. Although Lorenzo would never love her, he would always feel a genuine fondness for her, even while giving liberal vent to his sensuality in frequent relationships with other women.

Internal political tensions. Giuliano

We noted earlier that Piero the Gouty's son was characterized by his open political ambition: a novelty that not everyone in Florence was able to appreciate. Cosimo had always sought to wield his influence behind the scenes, considering it the best way to deflect envy and resentment; yet he too had to cope with bitter political strife. Lorenzo's situation was even more difficult, because suspicion was swiftly growing in certain quarters that the Medici wanted to take over and, truth be told, the fear was well-founded. Obviously, there were those who worried about the future of the Republic, and those gnawed by envy and the desire to find themselves in the Medici's shoes. The moment was drawing near in which the fear and spite of a few would degenerate into homicidal fury, forcing Lorenzo to confront tragic circumstances.

The last son of Piero the Gouty and Lucrezia Tornabuoni, Giuliano was born in 1453, four years after Lorenzo. Attractive, elegant and kind, he secured a special place for himself in the hearts of the Florentines. He will be forever linked to the event that inspired one of the major poetic works of the epoch: the *Joust of Giuliano de' Medici*, by Politian. In the same way that Luigi Pulci had done for Lorenzo, Politian immortalized this tournament in honor of Giuliano. Held in 1475 in the Piazza of Santa Croce, the joust was attended by distinguished guests from all over Italy, sporting

an array of costumes and armor the likes of which had never been seen in Florence or elsewhere. Giuliano wore a silver coat of armor with helmet and standard designed by Andrea del Verrocchio. Lucrezia Donati was once again Queen of the Joust, while Simonetta Cattaneo – Genoese by birth but newly-wed to Florentine Marco Vespucci – was elected as Beauty Queen.

Giuliano's feats during the tournament had a lasting resonance in the city: in addition to Politian's verses one finds the allegorical celebration of Sandro Botticelli, who portrayed the event in three great paintings descending directly from Agnolo's poem: the *Birth of Venus*, *Mars and Venus*, and the *Primavera*.

The **Surrender of Colle Valdelsa** in a manuscript conserved in the State Archive, Siena. The village, a strategic location between Florentine and Sienese territory, was attacked between 1478 and 1479 by the Pope and the King of Naples: this conflict was closely linked to the recurring tensions with the Florentine Republic.

Friction with Pope Sixtus IV. The Pazzi

Destiny, nonetheless, held a tragic future in store for Giuliano. Seven years earlier, in 1471, Francesco della Rovere had been ordained as pope under the name of Sixtus IV. One of Peter's least worthy successors in the history of the Church, Sixtus shamelessly pandered to his sister's three children – she had married a member of the Riario family, an aristocratic Roman household then in conflict with the Colonna. It seems that one of these nephews, Girolamo, advocated for the conquest of Florence, hoping to turn it into his own personal state. But there were other sources of friction between the Medici and the Pope. Sixtus IV wanted to expand his temporal power over Romagna – from Imola to Faenza, to be precise – in order to turn it over to his nephews for occupation. Lorenzo, on the other hand, had a manifest interest in maintaining the northern boundaries of the Republic intact, and thus entered in head-on collision with the ambitions of the Riario and the Pope. The latter had no compunction in backing the criminal scheme devised by Girolamo, that presupposed the death of Lorenzo and Giuliano in the takeover of Florence.

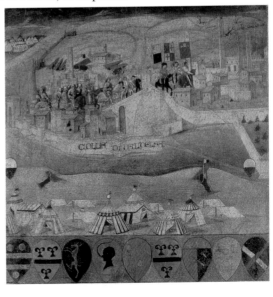

To realize the plan it was necessary to enlist the support of other sworn enemies of the Medici, foremost among which were the Pazzi, one of the oldest and most important Florentine families. The Pazzi boasted, among other things, a most distinguished ancestor: Pazzino, a participant in Godfrey of Bouillon's

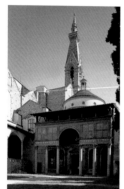

Crusade. Among the first to enter Jerusalem, he had brought back from the Holy Sepulcher the three flints – conserved in the small Church of Santi Apostoli – with which every year the "new flame" of the city was ignited. Bitter rivalry was inevitable between this antique, civic aristocracy and the Medici – newcomers to the city and ever more so to wealth.

The two families were joined by a marriage of convenience: Bianca de' Medici, daughter to Piero the Gouty and sister to Lorenzo and Giuliano, married Guglielmo de' Pazzi; but behind this episode of apparent pacification the old grudges continued to smolder beneath the ashes.

The Pazzi Conspiracy

Above: A view of the **Pazzi Chapel**'s exterior portico, crowned with its characteristic "loggia." A prototype of Brunelleschi's architecture, it rises to the southern side of the Basilica of Santa Croce.
Right: Andrea di Cione known as Verrocchio (1435-1488) sculpted his celebrated bronze **David** in 1476. Originally commissioned for the Medicean Villa of Careggi, where Lorenzo passed away, the work was sold to the Signoria and placed in the Palazzo Vecchio. In 15th-century Florence the figure of the young King of Israel was seen as emblematic of republican virtues.

The Riario had no problem in striking an accord with the Pazzi and their followers, notwithstanding the high probability that both families intended to dissolve the alliance after the coup and impose their own dominion over the city.

It seems that the plot was hatched in Rome in early 1478, with Sixtus IV's full collaboration. However, the assassination of the two Medici was only part of the plan: it was also necessary to arm forces ready to intervene in Florence directly following the assault. Thus, troops were sent to occupy Todi, Città di Castello, Imola and the area surrounding Perugia – key points in the confines of the Florentine Republic. Along with Girolamo Riario and the Pazzi, the conspirators included the Archbishop of Pisa Francesco Salviati, whom Lorenzo had apparently excluded from the Florentine post in favor of his brother-in-law Rinaldo Orsini. Less clear, on the other hand, is the role played by sixteen-year-old Raffaello Riario, the Pope's great-nephew. It would be he, at any rate, to set the wheels of the plot into motion. As newly-elected cardinal he had to go to Pisa in order to attend the university; as duty required, the city's archbishop – Salviati – would accompany him on the journey from Rome. Before reaching Pisa, the young cardinal would pay a courtesy call on the Medici and would most certainly be invited, along with Jacopo de' Pazzi and other exponents of the Florentine nobility, to attend a sumptuous banquet scheduled for April 25, Holy Saturday. That occasion would lend the opportunity to poison the two Medici brothers.

The banquet took place as planned, but Giuliano was unwell and did not attend. The execution was thus postponed until the next day, and different means

were devised. According to the revised plan, Lorenzo and Giuliano would fall under dagger blows in the Duomo during the celebration of Easter Mass. The great throng would facilitate the assassins' escape; at the same time Archbishop Salviati, along with other participants in the conspiracy, would occupy the Palazzo Vecchio, seat of the Florentine government.

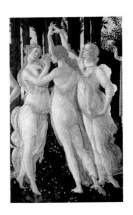

The following day around noontime the Medici and their retinue departed from Palazzo Medici for the nearby cathedral, where they took their places among the front rows. Upon the elevation of the Host the two brothers – who were seated in separate pews – knelt down; and in so doing were attacked by ruffians. Struck in the head, Giuliano died instantly, but the unappeased cut-throats flew into a frenzy over his lifeless body, in the end inflicting no less than nineteen wounds. Lorenzo had better luck: the blade of his precipitous attacker just grazed his throat. Unsheathing his sword, he ran towards the High Altar and, with his friends covering for him, made his way to the left sacristy – the so-called Mass Sacristy – and there barricaded himself.

Bloodshed notwithstanding, the coup had missed its mark. Moreover, news of the crime – all the more savage having been committed in a sacred place and on a day of peace – spread swiftly by word of mouth. After the first moments of confusion the crowd rioted and went on the hunt for the assassins. In the meantime the latter had managed to escape from the cathedral, trailing their leaders' procession in the direction of the nearby Piazza della Signoria.

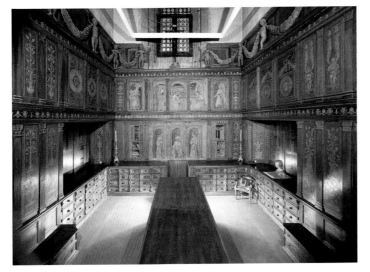

Above: The three Graces, in a detail from Sandro Botticelli's **Primavera** (Florence, Uffizi). Commissioned by Lorenzo di Pier Francesco, the painting was inspired by Platonic themes and by Politian's "Stanzas." The latter characterized brothers Lorenzo and Giuliano as "Dioscuri," and Lucrezia Tornabuoni as "Etruscan Leda." Left: Famous for its walls and cupboards decorated with wood inlay by Giuliano da Maiano (1432-1490), the **Sacrestia delle Messe** (Mass Sacristy) sheltered Lorenzo and his men during the ambush that claimed the life of Lorenzo's brother Giuliano.

Above: A macabre drawing by Leonardo da Vinci (1452-1519) depicts the lifeless body of **Bernardo Bandini Baroncelli,** hanged for his participation in the Pazzi conspiracy (Bayonne, Musée Bonnat). Below: Antonio del Pollaiolo's **medallion** commemorating the conspiracy (Florence, Bargello). Lorenzo's profile is accompanied by the Latin motto "salus publica" (public salvation). Giuliano's face appears on the opposite side, along with the inscription luctus publicus" (public mourning).

An exemplary vendetta

Archbishop Salviati entered the courtyard along with his following, but a certain agitation in gestures, certain fleeting glances and certain murmurings put the Gonfaloniere Petrucci on guard. Disguising his suspicions, he went about entertaining his guests, but meanwhile sent an emissary to ascertain whether things in the Duomo were going along smoothly. The news of Giuliano's murder and Lorenzo's injury arrived like a lightning bolt, and equally swift was Petrucci's response. Salviati's men were surrounded and stabbed to death, and the Archbishop himself was hanged. Little time passed before another twenty conspirators fell under the wrath of the Florentine state.

In the meantime a veritable man-hunt was under way in the streets of Florence: in the end the mob would leave behind some eighty corpses. Jacopo de' Pazzi, who managed to escape the city for refuge in Castagno (in the Mugello), was taken prisoner by the villagers and dragged back to Florence: he would be brought to justice in the Piazza della Signoria. There followed the executions of Francesco de' Pazzi – Giuliano's killer – and his cousin Renato, along with the other participants in the conspiracy. Only Guglielmo – Francesco's brother and Bianca de' Medici's husband – was pardoned by Lorenzo, but condemned to lifelong exile. The entire Pazzi family was done away with: the majority killed, the rest imprisoned or exiled.

Giuliano was buried in the Church of Santo Spirito, following a solemn funeral service attended by almost all of the citizenry. Giulio, his illegitimate child by Antonia Gorini, was welcomed into the palace and raised with Lorenzo's children. His illegitimate status would not prevent him from having an enormously prestigious future, ascending to the pontifical throne in 1523 under the name of Clement VII. Lorenzo emerged from the conspiracy with reinforced power and popularity, but from that day on Florence would enjoy no more jousts or tournaments. The time for merrymaking was gone forever.

The conflict with the Church expands

Notwithstanding his victory over the conspirators, Lorenzo's misadventures with the Church and the papacy were not over. Sixtus IV was unwilling to accept the defeat and abandon his claims over Florence and Tuscany. In fact, the years following the Pazzi Conspiracy were marked by a papal war against Florence, in which the Pope succeeded in enlisting Ferdinand, King of Naples, as well as Siena, Lucca, and Urbino.

It was the Pope himself to spark the conflict: he excommunicated Lorenzo and launched interdiction against the entire Florentine State for having inflicted the death penalty on Cardinal Salviati and the other conspiracy leaders. The Roman branch of the Medici bank was sequestered, and the Signoria was urged to turn Lorenzo over to the Pope. Naturally the Signoria refused to honor the request, and the Tuscan Church arrived at the point of open rebellion against the Vatican, excommunicating the Pope and justifying the action in a document disseminated to all Italian and European courts. Now the war was truly inevitable, and in its crusade the Papacy would find willing allies among the many who feared Florentine ascension. Due to the disparity of forces on the battlefield the Florentine army suffered more than one defeat, until at the end of 1479 Lorenzo resolved to seek a diplomatic solution to the conflict.

Lorenzo's political greatness

In an exceptional act of courage the Magnificent proceeded to Naples in order to negotiate with Ferdinand, who could have decided at any moment to deliver him into the hands of the Pope. Lorenzo sought to

Approval of the Order of St. Francis, by Domenico Ghirlandaio (Florence, Church of Santa Trinita, Sassetti Chapel). Lorenzo can be seen standing among members of the patron family. His sons Piero, Giovanni and Giuliano are also present, accompanied by their famous tutors: Politian, Matteo Franco, and Luigi Pulci (climbing the lower staircase).

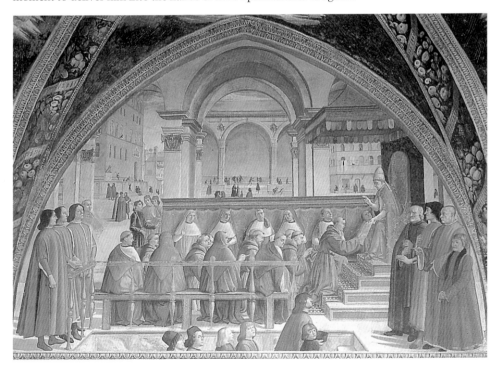

Sandro Botticelli, **Minerva and the Centaur** (Florence, Uffizi). The painting, commissioned around 1485 by the minor branch of the Medici family, has been interpreted as an allegory of Lorenzo's success with King Ferdinand, as arduous as it was unexpected. Not coincidentally, the Gulf of Naples can be made out in the background, while the goddess's cloak is studded with the three interlocking Medicean rings.

convince the King that the papal conquest of Florence would bring about indirect damage to the kingdom, as a large and potent pontifical state would irremediably alter the already fragile equilibrium among Italian states. In the course of three months, with laborious negotiations and remarkable expenditures on luxury gifts for the King and Queen, Lorenzo succeeded in securing the peace. The price was not a small one: the Magnificent had to pay an indemnity to the Duke of Calabria and would have to release, upon the Pope's request, some of the members of the Pazzi family still in prison. The Pope's other allies followed Ferdinand's example and withdrew from the conflict. In March 1480 Lorenzo returned to Florence in triumph, having further consolidated his personal prestige. Niccolò Machiavelli (eminent historian and one of the fathers of modern political theory) would thus describe Lorenzo's return to Florence: "Great upon his departure, he returned even greater, and his city received him with the gladness, that his fine qualities and fresh merits merited him, having risked his very life to bring peace to his country."

Although officially Lorenzo remained merely the head of the House of Medici, the European rulers justifiably considered him as a true sovereign, the *deus ex machina* of Italian politics. The Magnificent held no public office within the Republic, and yet remained effectively its leader. His prudent nature, nevertheless, kept him from the temptation of ratifying his role at the institutional level: he thus avoided a predictable reaction from the Florentines, forever loath to submit to the power of a single man. Lorenzo's international prestige, moreover, indirectly favored commercial trade with other European cities and capitals, where many were obliged to concede that Florence by now held a preeminent role in politics and culture.

Philosophy, poetry, literature

During Lorenzo's epoch the palace on Via Larga became a cultural reference point, not only in Florence and Italy but throughout Europe as well. As noted earlier, philosopher Marsilio Ficino – authoritative exponent of Renaissance Neoplatonism, who had been under Cosimo the Elder's protective wing – was one of the Magnificent's favorite intellectuals. Every year on November 7 Plato's birthday was celebrat-

ed with a fabulous banquet held in the villa of Careggi, attended by all of the friends in the literary circle of the Medici household.

If Ficino rose as protagonist in the cultural life of these years, the second, spiritual pole of the Laurentian circle was represented by Pico della Mirandola. Arriving in Florence from Emilia (Mirandola is a large village in the province of Modena), famed for his extraordinarily precocious erudition, Pico was welcomed at once into the Via Larga palace, finding friendship and protection. It was he who promoted the study of Hebraic culture, broadening the humanists' cultural background, previously confined to the Graeco-Roman world. Before long, Politian joined the Medicean inner circle: in 1473 he was taken in by Lucrezia Tornabuoni as mentor for her grandsons Piero and Giovanni, born from the marriage of Lorenzo and Clarice Orsini.

In these years the Italian language definitively took the place of Latin, even within the literary milieu. At a young age Lorenzo himself had learned the poetic language of Luigi Pulci, who had effectively become the family's official poet, welcomed by Cosimo the Elder in 1461. The Magnificent seemed the very personification of the humanistic ideal of politician, possessing gifts as scholar and philosopher. He was, in fact, a poet and writer: in his works one finds descriptions of daily, familial life, a realistic representation of Florentine lifestyle. At the same time his classical education rendered him prone to philosophical meditation, and to the debates typical of the humanist literary environment. Lorenzo was able to alternate a popular, colloquial jargon – used in his realistic representations – with a highly refined and courtly speech. In his amorous lyric poetry he adopted a sentimental tone of Petrarchian or *dolce stil novo* influence. Inspired by his teachers Ficino and Pulci, this double register allowed for a diversified literary production, as notable for its lyric poems (*Forests of Love*) as for the realistic short poems (among which *The Drunkards* and *Falcon Hunt*). His dominant themes included the authenticity of rural life and simple folk, as well as courtly love. Along with the typically humanist act of placing man at the center of the universe, Lorenzo also highlighted his mortal transience and the fickleness of his affections. It is not by chance that one of his literary manifestos remains the carnival song entitled *The Triumph of Bacchus and Arianna*, commencing with the celebrated lines: "Oh, how fair is youth and yet how fleeting! Let yourself be joyous if you feel it: of tomorrow there is no certainty." These verses reflect a significant aspect

The **miniatured manuscript** of a political treaty from the late 15th century (Florence, Laurentian Library). The Magnificent's profile appears to the right of the text. Below: Symbol of the Dominican order and recurring image in the works of the philosopher Ficino, the sun was placed on the façade of the Church of Santa Maria Novella by Leon Battista Alberti.

French-Burgundian art (15th-century), **vase** in violet and ochre jasper, gilded silver and pearl (Florence, Museo degli Argenti). Below: **Stories of St. John the Baptist** (Florence, Church of Santa Maria Novella), by Ghirlandaio. Marsilio Ficino and Cristoforo Landino, now old, chat with Politian, tutor of Lorenzo's sons.

of the personality of a man who, although immersed in Italian and international politics, had not lost the capacity to reflect upon the true meaning of life.

The Magnificent's contribution to the culture of his day was not limited to his literary works and to the diffusion of Platonism. For example, he ordered the compilation of the *Aragonese Collection*, an anthology of Tuscan poetry from the 13th and 14th centuries, sent as an offering to Frederick of Aragon. A considerable share of the family's estate was spent in the procurement of ancient manuscripts, which his messengers went in search of as far as the distant Orient: they would constitute the initial core of the Biblioteca Laurenziana ('Laurentian Library'), housed in the Basilica of San Lorenzo. Dozens of scribes and miniaturists were employed to copy and illustrate the manuscripts, which for the first time attained widespread circulation.

Lorenzo also deserves credit for the rebirth of the University of Pisa, already famous throughout Italy but at the time in a state of decline. In 1472 the Magnificent decided to raise it to the rank of top Tuscan university, personally financing it with generosity. He then proceeded to found the Florentine University, the only in Europe where one could study Greek. Many illustrious Greek scholars who had fled to the West after the fall of Constantinople (1453) were recruited to teach here. In 1488 they completed the first printed edition of the Homeric poems.

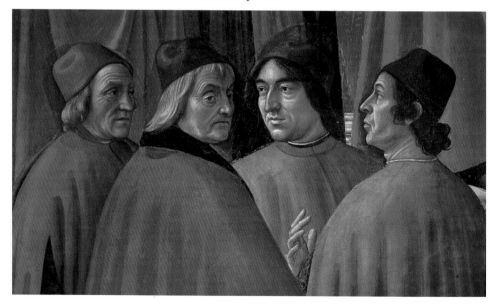

Love of the arts

In addition to literature Lorenzo was profoundly enamored with the figurative arts, and became an able connoisseur and avid collector. In the courtyard between his Via Larga mansion and San Marco – the so-called Medicean Orchards – he founded a school of sculpture that would be attended, among others, by young Michelangelo Buonarroti. On the subject Giorgio Vasari described a curious episode in his *Lives of the Artists*. The story goes that Lorenzo noticed Michelangelo for the first time while the youngster was intent on copying the head of an aged faun, and was dumbstruck by his precocious skill: Michelangelo had in fact deviated from the model giving free rein to his own creative instinct, and had sculpted the faun with lips parted, revealing a perfect set of teeth. The Magnificent brought to his attention the fact that generally the teeth of the elderly are not all intact; Michelangelo, then, obligingly chipped one off in order to render the figure more lifelike.

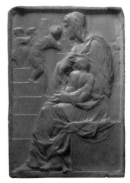

Madonna della Scala
(Florence, Casa Buonarroti), one
of Michelangelo's first works.
Below: 15th-century Venetian
art, **vase** in jasper, gilded
silver and enamel (Florence,
Museo degli Argenti).
Inscribed with Lorenzo's
name, this precious object
belonged to his extensive
private collection.

Subsequently, the future master of the Sistine Chapel was welcomed into the Medici household and treated like a son: he attended the school and received a stipend, sat at the same table as Lorenzo and had a room of his own in the palace. He remained there for four years, until in 1494 the Medici were once again driven from Florence.

Family affairs

Peace with the Pope and his allies left Lorenzo free to dedicate himself to his favorite activities: literature and the fine arts. In the meantime, however, the Medici family suffered some heavy losses. In 1482 Lucrezia Tornabuoni – adored and attentive mother, as well as shrewd advisor to her son – passed away. Five years later Lorenzo's wife, Clarice Orsini, died at the age of thirty-four.

In 1484 Sixtus IV died as well, succeeded in St. Peter's by a pope much closer to the Medici: Innocent VII, secularly known as Giambattista Cibo. Before taking his oaths Innocent was married with children. In fact, his son Francesco married Maddalena, daughter of Lorenzo and Clarice, in 1488. In the same year Lorenzo's first-born son Piero wed Alfonsina Orsini, who belonged to his mother's house. For his second-born, on the other hand, the Magnificent chose the ecclesiastical route: in 1483, at the young age of seven, Giovanni had already received the abbacy of Fontdouce from

The Villa of **Villa of Poggio a Caiano**, designed by Giuliano da Sangallo in 1485, was Lorenzo's preferred residence: only seldom would he bring himself to join his wife and children in Cafaggiolo. Upon his death the villa was passed on to his son Giovanni, who had the interior decorated with allegorical images celebrating the family. The work, initiated by Andrea del Sarto and continued by Franciabigio and Pontormo, was completed by Allori at the end of the 16th century. The villa's appearance has changed considerably since Lorenzo's day: Buontalenti reconstructed the exterior wall in 1570, and in 1807 a semicircular staircase replaced the original ramps. Other transformations date to the second half of the 19th century, when the villa served as vacation home to Vittorio Emanuele II, King of Italy.

Louis XI of France. Pope Innocent would prove even more generous, naming him cardinal at the age of thirteen. It should come as no surprise that in this epoch the attribution of the cardinalate was often independent from religious vocation and even, not uncommonly, from the order of the priesthood. Strictly speaking, a cardinal was merely a prince of the Ecclesiastical State, empowered by the pope as worldly sovereign. The value of the position – more political than religious – represented a bartering chip or gift made by the pope to guarantee the support of a particular family.

The inflexible Fra Girolamo. The end of the Magnificent

And yet Lorenzo's problems with Catholicism persisted. Having mended relations with the Pope and the Papal State, now the figure of a Dominican friar – Girolamo Savonarola – loomed on the horizon, destined to cause remarkable turmoil in the political and social life of the city. Paradoxically, the Ferrarese Savonarola moved to Florence at the specific request of Lorenzo, perhaps upon the advice of Pico della Mirandola, impressed by his undeniable gifts as preacher.

In 1490, a year before his election as prior of San Marco's convent, the fiery Dominican commenced his famous sermons against social corruption. His would be a tirade from which not even the Church was spared, for which he prophesied imminent ruin along with the collapse of the old orders. Orator with apocalyptic overtones, inspired to a radical asceticism, he resolutely condemned all forms of worldliness,

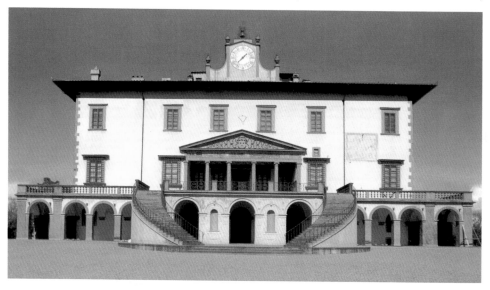

and considered Florence to be profoundly corrupt, driven by pleasures and lust. The Magnificent himself, remote from this gloomy moralism, was held responsible for the "de-christianization" of the city. Fra Girolamo became the spokesman of the desperate, and the crowd followed him in the hopes that the promised divine intervention would translate into an opportunity for social upheaval. In contemporary jargon we would characterize him as a "fundamentalist," animated by the conviction that political leaders should draw their inspiration directly from God – in other words, a supporter of the form of government known as theocracy.

It would be difficult to say with certainty what Lorenzo really thought about the prior of San Marco, or about the continual attacks launched at him from the pulpit. What can be said, however, is that he never responded to Savonarola's political or personal provocations and that he actually went to listen to him whenever he could. Superior indifference or precise political design? We don't know. It is not inconceivable that the Magnificent detected a certain truth as far as the moral depravity of the Church was concerned. It was not by chance that upon his deathbed Lorenzo would want that very same critic Fra Girolamo at his pillow.

Lorenzo had suffered from the family illness for years – the gout that drove him from Florence ever more often to seek therapeutic thermal waters, although unfortunately with negligible results. Feeling close to the end, in March 1492 he had himself transported by stretcher to his beloved Careggi villa, followed by his faithful friends Politian and Pico della Mirandola. There he would be met by Savonarola, who heard his confession in the presence of Politian. According to one version of the story, the friar asked Lorenzo to liberate Florence before dying and, faced with his refusal, had in turn denied his benediction. However the episode, which depicts Savonarola as a ruthless fanatic unmoved even in the face of death, is more likely a legend circulated by the priest's detractors; and in fact the episode is conspicuously absent from Politian's memoirs.

The Magnificent passed away on April 8 1492, just forty-three years old, leaving Tuscany and Italy overall in a very difficult situation.

Lorenzo's death mask. This somber testimony provided the model for a succession of artists – most notably Giorgio Vasari – in reproducing the semblance of the Magnificent. In addition to gout, an illness afflicting almost all of Cosimo the Elder's descendants, Lorenzo inherited from his maternal ancestors a peculiar nasal deformity which deprived him almost entirely of the senses of taste and smell. Below: **Madonna and Child**, by Michelangelo. The group watches over the sarcophagus of Lorenzo and Giuliano de' Medici (Florence, Church of San Lorenzo, New Sacristy).

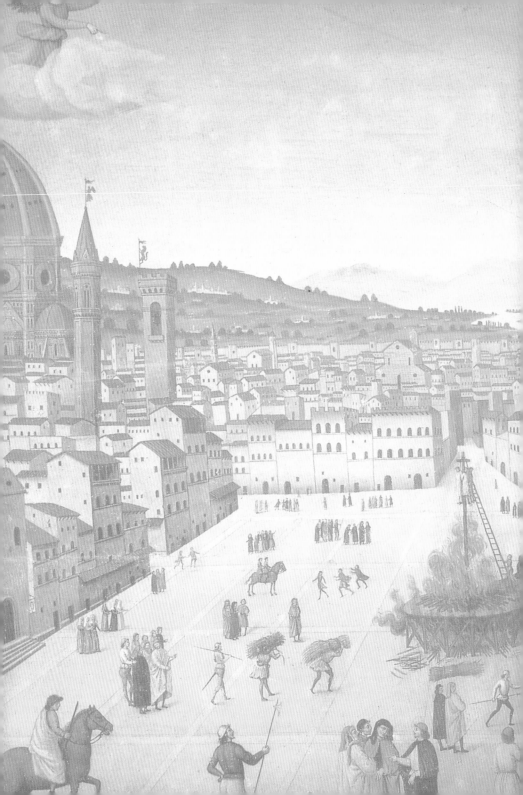

Approaching princedom

In Florence the republican ideal reblossomed with the arrival of the mystic Dominican friar Girolamo Savonarola. His sermons goaded the city's conscience, and managed to reconfigure the political landscape. After his death only the crushing force of imperial troops would succeed in reestablishing the Medici within the city walls. They returned, this time as the holders of absolute power.

Piero: a brief interlude

With Lorenzo's death, the family scepter passed into the hands of his first-born, Piero, born in 1471. Just twenty-one years old, he had already earned himself the nickname of "the Unfortunate" for his incapacity to execute any type of project; but perhaps misfortune entered into the picture only up to a certain point. His wife was another Orsini, Alfonsina: worse than Clarice, she would prove to be coarse and unpleasant, and would never succeed in fitting into her Florentine setting. This was yet another obstacle to Piero's popularity, who was already looked upon by many in the city with an unkind eye.

Piero's "baptism of fire" was formidable: Charles VIII of France descended into Italy at the head of an army, determined to conquer the Kingdom of Naples. Truth be told, the sovereign had no particular designs on Florence, apart from the fact that his troops would have to pass through territories subject to the City of the Lily. Embarking from Vienna in August 1494, by autumn the transalpine militia had occupied the fortress of Sarzana, poorly defended by the troops that Piero was able to pull together. Following this military misadventure, Piero approached Charles in the hopes of dissuading him from the Florentine route. The diplomatic bid turned out to be a half-failure: although agreeing not to occupy Florence, the King refused to renounce passage for his troops – a matter of undeniable political significance. Moreover, he obtained go-ahead for the occupation of Pisa and Livorno, as well as the fortresses of Sarzana, Sarza-

Piero the Unfortunate, also known as the Fatuous, by the school of Bronzino (Florence, Uffizi). After his ill-fated negotiations with Charles VIII of France, he was exiled from Florence. He perished in a shipwreck off Gaeta.

Francesco Granacci (1469-1543), **Charles VIII enters Florence**. The King of France and his retinue, housed in the Medici palace on Via Larga (to the extreme left), were "welcomed" by the Signoria with all fitting honors; yet the sovereign's irritatingly presumptuous attitude aroused considerable animosity. When the King accompanied his umpteenth request with the threat to sound his battle trumpets, Pier Capponi replied: "And we will ring our bells," alluding to the toll of the Martinella bell that would summon the people to assemble. Impressed by such determination, Charles assumed a more conciliatory stance; so forceful had been what Machiavelli, in characteristic style, later referred to as "la voce di un cappon fra tanti Galli" (the voice of a capon amidst so many roosters): a clever pun, since "cappone" means capon, or castrated rooster, and "galli" can mean both roosters and Gauls (Florence, Uffizi).

Right: **Judith and Holofernes**, by Donatello. The splendid bronze group, today in Palazzo Vecchio's Sala dei Gigli, was confiscated by the Republic for its symbolic value, and placed in Piazza Signoria along with an inscription denouncing tyranny.

nello, Ripafratta and Pietrasanta. On November 8 Piero returned to Florence, expecting to enjoy the favor of the citizenry for what he considered to be a partial success. But he would be bitterly disappointed.

Among the Priors or city government, as well as public opinion, many considered him akin to a traitor, having capitulated to the foreigner without a fight.

The final failure of an unfortunate Medici

The consequences were catastrophic. For the second time in seventy years, the Medici, viewed as enemies of the fatherland, were banished from Florence by the Signoria. What's worse, two of Piero's cousins, Lorenzo and Giovanni (sons of Pier Francesco de' Medici and therefore belonging to the secondary branch of the family) took an active part in the decision. The Magnificent's European prestige had, in fact, provoked friction and rivalry between the two branches of the family, and the two cousins voted for the exile of Piero "the tyrant."

Piero and his brothers – Giuliano and Cardinal Giovanni – were forced to flee. Actually, the latter had already been obliged to leave Rome in a hurry, fearing the vendetta of the new pope Alexander VI (secularly known as Rodrigo Borgia), whose election he had hampered during the conclave.

Piero and his loved ones – including Giulio, Giuliano's illegitimate son – departed in the middle of the night, under the specter of popular fury. They carried their money and precious items with them, but the abandoned palace on Via Larga was sacked by a ferocious crowd, and stripped of the majority of its furnishings. For its part, the *Signoria* confiscated close to 20,000 ducats deposited in the Medici bank, and placed a bounty of no less than 4,000 florins on Piero's head.

The first years of exile found the three brothers crusading from one Italian state to the next, trying to rally armed backup for their return to Florence. Piero would thrice attempt to reconquer the city, but his constant failures ended up convincing the other family members to abandon him to his own destiny. He then tried to win the favor of Charles VIII by joining forces with the French army in its campaign for southern Italy, but in the end would procure for himself only an inglorious death. In 1503, while transporting four heavy pieces of artillery towards Gaeta, Piero's craft was shipwrecked and he himself vanished among the waves.

For their part Giovanni, Giuliano and Giulio had abandoned Italy back in 1499, traveling through Germany, the Netherlands and France. Upon their return the three Medici sought refuge in Rome, where Pope Alexander VI – forgiving his old grudge against Giovanni – welcomed them with benevolence.

Fra Bartolomeo (Baccio della Porta know as, 1472?-1517) depicted **Girolamo Savonarola** in the black hood characteristic of the Dominican habit (Florence, Museo di San Marco).

A friar at the head of the Republic

Having banished the Medici from the city, the Signoria now had to confront the very serious problem of Charles VIII and his troops, who had in the meantime conquered Pisa. Charles refused to heed the Florentine pleas and eventually entered Florence in full regale. Here Savonarola, ever more comfortable in his role as herald of divine will, greeted the Very Christian King as a liberator. The sovereign took up lodging in the palace on Via Larga, and informed the Signoria of his conditions that – remaining those of his agreement with Piero – were firmly rejected. The King then threatened to sound the trumpets in order to prepare his soldiers to sack the city. In reply, Senator Pier Capponi uttered the famous line that would earn him a statue under the loggia of the Uffizi as savior of the fatherland: "If you sound your trumpets, we will ring our bells."

Charles realized that mobilizing his army against the entire citizenry would be an act of grave imprudence, and thus agreed to revise some of the clauses in the treaty. Nevertheless, Florence would be forced to surrender Pisa, Sarzana, Sarzanello, Ripafratta and Pietrasanta. These cities and fortresses, needed as an escape route in case of withdrawal, would be returned to the Republic upon

Originally housed in Careggi and later moved to the family palace on Via Larga, the extensive Medici library was confiscated by the Florentine Republic. Savonarola then had it transferred to San Marco (above, the **convent library**). Below: In the Sant'Antonino cloister of San Marco one finds the **"Piagnona"** (Wailer): the bell was hammered in a vain effort to mobilize the public to defend Savonarola, condemned to burn at the stake.

his conquest of Naples. Moreover, the Florentines would have to pay the enormous indemnity of 120,000 ducats. Two days after signing the agreement, the King left Florence and set his path for Naples.

After the departure of Charles and his army the city entered into a phase much different than the one hoped for upon the ousting of the Medici. Without a guide Florence slipped back into the state of perpetual internal conflict that for centuries had been its peculiar characteristic. This situation favored Savonarola's unstoppable political ascent. In the last years of the 15th century the friar, far from limiting himself to the salvation of souls, ruled the city like an authentic religious (and political) despot.

Savonarola formed the Grand Council, open to all citizens over the age of twenty-nine who had previously held office in the magistrature or who were the descendants of high magistrates. The Council could accommodate up to one thousand members, each serving a six-month term in office: the body was too vast to make rapid decisions and the tenure too brief to assure even a minimum of continuity. In short, it seemed specially designed to *not* govern. In fact, the true government wound up in the hands of the Dominican, who implacably pursued his mission of fighting the excesses and immorality in which Florence was presumably immersed, guilty of not adequately expiating the Original Sin. The city, until so recently brimming with *joie de vivre*, now seemed caught up in a strange penitential fury, driven by the preacher obsessed with sin. Many noblemen gave up their secular lifestyle to don the religious habit, and numerous artists likewise abandoned worldly subjects to paint and sculpt only episodes from the life of Christ, the Virgin Mary and the Saints. Not uncommonly, as was the case with Fra Bartolomeo, they went as far as burning their old canvases. This atmosphere of universal contrition reached its climax with the famous 'Bonfire of the Vanities,' held in the Piazza della Signoria during the Carnival of

1496. The citizens gathered to feed its flames with clothing, jewels, wigs, books, pictures and all other sundry reminders of their sinful past.

A pyre in Piazza della Signoria

Not everyone, however, agreed with Fra Girolamo. An anti-Savonarolian party was formed, who longed to liberate the city from its cowled dictator: it was the party of the Arrabbiati ('Angry Ones'), opposing the priest's followers, the so-called Piagnoni

('Wailers'). In any case the twilight of the great moralizer was drawing near. Although most Florentines had still not shown open signs of intolerance, Pope Alexander VI had had about enough of the Dominican's daily sermons, haranguing not only the city but also the Church State and its widespread dissolution. At the end of 1497 the Signoria received a pontifical delegation inviting the Florentine leadership to turn Savonarola over to papal justice.

This measure was finally taken in April of the following year. The friar, who had lost much of his earlier support, was arrested and imprisoned in the Palazzo della Signoria, where he was interrogated and tortured before the arrival of the Pope's emissaries. Once in Florence, these presided over a brief trial. Eventually Savonarola was condemned to death along with two of his fellow friars, Domenico Buonvicini and Silvestro Maruffi. The morning of May 23 1498, the three were hanged and burned at the stake in front of Palazzo Vecchio, the very spot – commemorated today by a round plaque – where two years earlier the Florentines had consigned their vanities to the flames.

After Savonarola's death the factions hurled themselves back into the struggle for power. To remedy this state of virtual anarchy the city resorted to the election of a life-long gonfaloniere who would assuming the functions of the antique podestà and should therefore offer the maximum guarantee of impartiality. The job fell to Pier Soderini,

Anonymous Florentine of the 16th century, **The Agony of Girolamo Savonarola and his Followers**. Displayed in the Museo di San Marco, this painting minimizes – perhaps intentionally – the drama of the execution: in fact, the event was witnessed by the entire civic body.

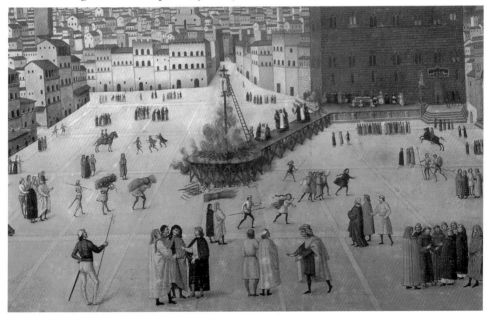

Andromeda liberated by Perseus, by Piero di Cosimo (1462-1521). Commissioned by Filippo Strozzi, the painting alludes to the return of the Medici in 1512. In 1589 it was put on display in the Tribune of Palazzo Vecchio, where it would remain for the next two centuries (Florence, Uffizi). Below: The **Genius of Victory**, today in Palazzo Vecchio. The group was probably part of Michelangelo's original plan for the tomb of Pope Julius II della Rovere, in the Roman Church of San Pietro in Vincoli. The enigmatic work has been interpreted as symbolic of the Florentines' lost liberty.

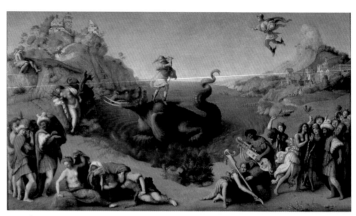

an honest but ingenuous man who lacked any particular political skill. Machiavelli, although counted among Soderini's friends, left us this scathing epigram about him: "The night Pier Soderini died / his soul went to the mouth of Hell. / But Pluto shouted at him: 'Silly soul, / Go up to Limbo where the other babies are!'."

The Florentine Secretary's futile advice

In these first years of the 16th century Florence watched its international prestige dwindle away. Besides, Italy overall was experiencing a relentless political decline. By now France and Spain considered it little more than a battleground on which to contend for supremacy, while Pope Julius II della Rovere (elected in 1503) donned helmet and armor, personally leading his troops to conquer new territories for the Church. Being allied with France, Florence became one of the Pontiff's internal enemies. Meanwhile Cardinal Giovanni, in Rome since 1499, succeeded in winning the grace of the new pope, and in convincing him that it was in his best interest to bring the Medici back to Florence. In 1512 the Spanish troops of the Holy League – formed on Julius II's initiative – marched on Florence, Giovanni at their side. In Florence the republican government presided over by Pier Soderini decided to resist, organizing a 'civilian militia' upon the advice of Niccolò Machiavelli.

A founder of modern political thought, Niccolò Machiavelli (1469-1527) is a figure of such stature that he merits considerably greater attention than the necessarily cursory reflections included herein. We will limit ourselves to remembering how he united theory and practice, dedicating fifteen years of distinguished service as Secretary to the Second Flo-

rentine Chancery: thus his theoretical research was constantly checked against the proof of practice. In his masterpiece, *The Prince*, Machiavelli described the conditions necessary to establish and maintain personal power, intentionally abstracting from all moral – not to mention moralist – considerations that might limit a ruler's freedom of action. According to the Florentine Secretary the true politician must devise and then employ all means necessary to attain his desired goal; in other words – to quote the somewhat simplified formula that has become immensely popular – the ends justify the means.

As far as the civilian militia was concerned, Machiavelli argued in *The Prince* that a state – and particularly a republic – should never entrust its defense to mercenary troops. The soldiers of fortune could guarantee no form of loyalty: they may be with you today but tomorrow – if left unpaid or offered more elsewhere – would not hesitate to join enemy ranks. A well-founded republic, on the other hand, required a citizen army. Only this could ensure – at least in theory – the soldiers' commitment to the cause, and a genuine interest in defending it to the very end.

At any rate, the Spanish troops allied with the Pope soon gave an appalling demonstration of their ferocity and determination, thwarting all Florentine hopes. At the end of August 1512 they seized Prato (situated a few miles north-west of Florence), subjecting it to two full days of fire and bloodshed, and slaughtering some two thousand people. Immediately thereafter an embassy arrived in Florence inviting Pier Soderini to surrender. The Gonfaloniere and other staunch republicans took to flight, and on September 1 the Medici returned to Florence after eighteen long years of exile.

A Medici in St. Peter's

Giovanni and Giuliano thus returned to the palace on Via Larga, along with Giulio and Alfonsina (Piero's widow) and her son Lorenzo. Piero and Alfonsina's other child, Clarice, was married off to Filippo Strozzi in 1508.

Cardinal Giovanni didn't linger long in Florence, opting instead to return to Rome with his cousin Giulio and entrusting the family to his younger brother, Giuliano. He had very good reasons to hasten back to the Eternal City: Julius II's death seemed imminent. And in fact the

In 1510 Pier Soderini ordered the **Signoria Altarpiece** from Fra Bartolomeo. The work was destined for the Sala del Gran Consiglio in Palazzo Vecchio, where the republican parliament convened following the Medici's exile in 1494 (Florence, Museo di San Marco).

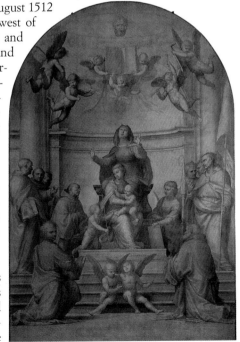

Pope drew his last breath in February 1513. This time the very same Giovanni de' Medici took his place, adopting the name of Leo X. Giovanni's election not only lent the Medici an unprecedented prestige, but also determined important changes in the family's set-up in Florence. While Giuliano was promptly summoned to Rome as gonfaloniere of the papal army, Lorenzo – Piero and Alfonsina's son and grandson to the Magnificent – assumed the role of head of the house. In 1515 Giuliano was sent to France as pontifical liaison with Francis I's court, and received from the King the title by which he would be remembered: Duke of Nemours. With a character almost as mild as his famous namesake in the Pazzi Conspiracy, Giuliano was not ambitious, nor did he think much of titles and glory. He died in the Badia Fiesolana on March 17 1516 – just thirty-seven years old – and it seems that his loss caused genuine grief. In France he had married Philiberte of Savoy, Francis I's young aunt. The couple had remained childless, but Giuliano left behind an illegitimate son, Ippolito: born in Urbino in 1509, he was destined for the cardinal's hat.

Lorenzo the Anything-but-Magnificent

In his first years as head of the Via Larga household Lorenzo conformed – at least in appearance – to the rules laid down by the Pope and by his cousin Giulio, the real seat of power being in the Vatican and not on the banks of the Arno. The only thing that Lorenzo inherited from the Magnificent was his name. He was a gloomy and irascible character, with a thirst for power unmatched by any real political competence. For example, ignoring the Pope's sage advice, he had himself dubbed Captain General of the Florentines, a title reserved to foreigners by ancient statute. Giuliano's premature death, moreover, allowed him to inherit the title of Captain of the Church, which Leo X apparently granted him with some reluctance.

Nevertheless, Lorenzo was certainly not the only ambitious character in the family. The Pope himself developed plans to enlarge the Medici dominion by conquering the Duchy of Urbino, a possibility granted by his brother's death. Giuliano had firmly opposed the plan, honoring a debt of gratitude to Urbino's ruler Francesco della Rovere for having hosted the Medici during

their years of exile. Lorenzo and his mother Alfonsina had also passed some years in the Urbino court, but now neither seemed anxious to demonstrate their gratitude to those who had helped them through the hard times.

The papal troops entered Urbino on May 30 1516, ousting Francesco della Rovere and clearing the way for Lorenzo. The new duke was not destined, however, to enjoy his title in peace: refusing to relinquish his legitimate rights, Francesco della Rovere launched a military campaign that would last for some months. Lorenzo himself set foot on the battlefield only once, and suffered a head wound. From that day forth he thought it best to avoid the risks of combat, persuading his uncle to hire instead the mercenary captain Prospero Colonna. The costs of the war started to weigh on his Florentine subjects, and what was before a tepid tolerance degenerated into hatred.

At any rate Pope Leo X did not abandon his nepotistic ways and along with cousin Giulio (whom he had created cardinal) decided to consolidate the position of the new duke of Urbino with a marriage of great prestige. His choice fell upon Madeleine de la Tour d'Auvergne, a distant relative to Francis I. Celebrated in the royal castle of Amboise in May 1518, the wedding was truly princely, with festivities lasting three full days. Returning to Florence in October, his wife already pregnant, Lorenzo by now felt that all of his ambitions had been realized: but in spite of his young age he was already afflicted by a severe form of tuberculosis that would lead him to the grave on May 4 of the following year. Madeleine died while bringing a daughter to light, preceding her husband to the tomb by just six days. Once again, death knocked

During his last years Andrea del Sarto (1486-1530) painted the **Medici Holy Family** (Florence, Palazzo Pitti, Palatine Gallery) for Ottaviano de' Medici, Cardinal Giulio's intermediary for artistic commissions in Florence. Below: The statue of **Lorenzo, Duke of Urbino** crowns the Medici's magnificent funeral monument, sculpted by Michelangelo for the New Sacristy in San Lorenzo.

Pope Leo X bought back the family library and moved it to Rome. The inestimable collection of manuscripts – started by Cosimo the Elder with the collaboration of humanists, notably Vespasiano da Bisticci, Poggio Bracciolini and Niccolò Niccoli – is currently conserved in the **Laurentian Library** (right). Among its precious treasures: the 10th-century manuscript known as Laurentianus 32.9, the oldest known source for all of Aeschylus and Sophocles' extant tragedies; the two Medicean codices of Tacitus, containing the only remnants of his "Annals" and "Histories;" a manuscript of Boccaccio's "Decameron" copied directly from the original; and the autograph of Cellini's "Life." Construction on the library, designed by Michelangelo, was completed by Bartolomeo Ammannati and Giorgio Vasari during the second half of the 16th century.

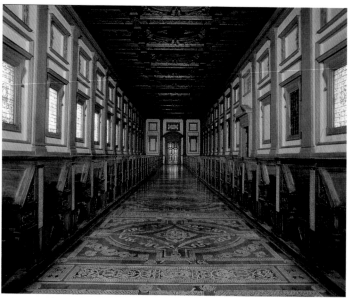

prematurely on the door of Casa Medici, indirectly confirming the wisdom contained in the Magnificent's verses: "Let yourself be joyous if you feel it: of tomorrow there is no certainty."

Leo X: a controversial pope

Lorenzo's death left Pope Leo with more than just one problem on his hands. For one thing, he would have to repair the damage done by his nephew during his albeit brief stint as head of the house; for another, he would have to worry about succession. At this point the only legitimate heir to the House of Medici was Caterina (Lorenzo and Madeleine's new-born daughter), as Ippolito (child to Giuliano, Duke of Nemours) was illegitimate.

Hoping to revive the Medici's waning popularity, the Pope sent Cardinal Giulio to Florence. In the course of five months Giulio succeeded in generating considerable good will. His recipe was simple and effective: he reduced taxes, restructured finances, reformed the administration of justice and, above all, returned to the electorate the rights that Lorenzo had usurped. In October 1519 the cardinal returned to Rome, resuming his post at the side of his cousin Giovanni. The latter persisted in his expansionist politics, at times with favorable results, as in the conquest of Perugia; other times – as in the case of Ferrara – less successfully. In any case Leo was not just a warrior: this first Medici pope was a multifaceted char-

acter. His boundless love of good food was proverbial, with the corollary of endless banquets celebrated in the company of pleasure-seeking prelates. To get an idea, it is enough to look at the celebrated portrait by Raphael, in which Giovanni appears quite hearty and plump. Then there was hunting, another of his great passions, which used to keep him occupied for days on end. At the same time he had an undeniable love of culture, resulting in a Laurentian level of patronage that drew legions of artists and intellectuals to Rome. The University would be founded during Leo's papacy, as well as the first printing house equipped with Greek types.

The Church in turmoil

Leo's most momentous act, however, was the promulgation of his bull on indulgences entitled *Sacrosancti Salvatoris et Redemptoris nostri*, dated March 31 1515. Having inherited the onerous burden of completing St. Peter's from his predecessor Julius II, the Pope had to attempt to revive the Vatican coffers, already weakened by the enormous expenses of the papal court. Consequently, he devised an expedient that deserves a brief digression.

When a man succumbs to sin he can, in the case of sincere penitence, obtain the remission of guilt by making a confession. The priest "absolves" him – that is, he "releases" or frees him from his sins. That is the meaning of the Latin formula, *Ego te absolvo a peccatis tuis*, with which the sacramental practice closes. Now the believer is no longer in a state of sin, but this does not mean at all that he will be spared from serving his punishment. This consists in a period

Pope Leo X's monumental coat-of-arms decorating the façade of Palazzo Pucci (on the corner of Via de' Servi and Via de' Pucci) was crafted by Baccio d'Agnolo.

Below: The decoration of the Villa of Poggio a Caiano was ordered by Cardinal Giulio and Pope Leo X. In 1532 Jacopo Carucci known as Pontormo (1494-1556) took over where his master Andrea del Sarto had left off. This lunette, now restored, bears the motto of Giuliano, Duke of Nemours: "glovis," an abbreviation of the Latin "gloria" (glory) and "vis" (strength).

The **Veronica** was commissioned to Pontormo on the occasion of Pope Leo X's visit to Florence in 1515 (Church of Santa Maria Novella, Popes' Chapel).

of time, of variable length, that the soul of the defunct must pass in Purgatory before ascending to the glory of Heaven. To prevent a person from having to pass such a sentence in the afterlife, the Church may grant him an "indulgence," either partial (a "discount" on the years in Purgatory) or "plenary" (complete remission). This can be obtained not only by the living on their own behalf, but also on behalf of those already passed away by means of "intercession" – that is, the celebration of masses and the doing of good deeds in their memory.

Leo's idea, outlined in his *Sacrosancti* bull, consisted in the selling of indulgences, thus trafficking a prerogative that according to Catholic doctrine the Church had received directly from the hands of Christ. Hence the polemic reaction of many Northern European Christians, already exasperated with the luxury and waste in the Vatican. The most lucid standard-bearer of this position was the German Augustinian monk Martin Luther, who on October 31 1517 affixed his Ninety-five Theses sharply criticizing the indulgences – and especially those for the dead – on the door of the Wittenberg cathedral. The following year Luther sent Leo a copy of his *Resolutions to the theses on indulgences*. A heresy trial against Luther was opened in Rome, presided over by the Pope himself. On May 2 1520 a papal bull threatened the monk with excommunication should he refuse to withdraw his opposition. On December 10, having sent a series of unanswered letters to the Pope, the Augustinian publicly performed an act of open rebellion against the Roman Church, burning the Code of Canon Law as well as the bull of excommunication. This marked the beginning of a reform movement that would bring about one of the greatest upheavals in European history. Leo X, however, had just enough time to witness its first phases, as he died of pneumonia on December 1 of the following year. He was not succeeded by one of his relatives, as he would have wished, but rather by the Flemish Adrian of Utrecht, ordained as pope with the name of Adrian VI.

Cardinal Giulio, who had hoped up until the last minute to be chosen as pope, returned to Florence to take the family business back into his own hands; however, his aspirations would not be long deferred.

The new pope, a humble man sincerely committed to purging corruption and excess from the Vatican court, made bitter enemies in Rome and throughout Europe, so much so that his death (September 14 1523, after just twenty months of pontifacy) is attributed by some historians to poisoning. This theory is plausible, although probably untrue: a moralizer at the helm of the Church in those days must have appeared an absurdity and a danger.

Clement VII, the second Medici pope

The papal throne was once again vacant. On November 19, after fifty days of conclave, Giulio – notwithstanding his status as illegitimate child – was made pope with the name of Clement VII.

The new pope's first problem was, yet again, family-related. Two cousins, both illegitimate, had been living for some years in the Via Larga palace: Ippolito, the natural son of Giuliano, Duke of Nemours; and Alessandro, who Clement passed off as illegitimate child of Lorenzo, Duke of Urbino, but who was probably his own son, born from a relationship with a peasant from the Roman countryside or else a slave of Slav origin.

In addition to living under the same roof the two cousins coexisted politically, since Leo X – between wars and banquets – never got around to designating the new head of the household. He had limited himself to naming Caterina (Lorenzo and Madeleine's daughter) Duchess of Urbino, annexing the duchy into papal territory. In certain respects the situation was paradoxical and also a little ridiculous: two illegitimate Medici at the helm of the family, legitimated only by a pope from the same house. Clement did not address the issue, going only so far as to send Cardinal Passerini to Florence – later joined

With its revolutionary use of double columns nested to close the angular pilaster, the **vestibule of the Laurentian Library** represents one of Michelangelo's most profound and innovative architectural feats. In 1523 Pope Clement VII brought back to Florence the volumes that Leo X had moved to Rome to prevent their dispersal. Left: **Pope Clement VII**, Giuliano's natural son, in a painting by the school of Bronzino (Florence, Uffizi). The prototype for portraits of Clement is to be found in a painting by Sebastiano del Piombo, today in the Neapolitan museum of Capodimonte.

Between 1529 and 1530 Florence found itself under siege by Charles V's imperial troops returning from the Sack of Rome (1527). After valiant resistance (especially famous is the episode of Gavinana, near Pistoia, that resulted in the heroic death of Florentine commander Francesco Ferrucci), the Republic was forced to capitulate: no longer rich as it used to be, the city had moreover suffered recurrent outbreaks of the plague. During the epidemic of 1523 Andrea del Sarto, seeking refuge in Mugello, painted an intense **Pietà** (below) for the Church of San Pietro a Luco (Florence, Palazzo Pitti, Palatine Gallery).

by Cardinals Cibo and Ridolfi – with the immediate aim of keeping the two youngsters in check. Then he dedicated himself entirely to the affairs of the Papal State, that would soon have to confront the two great rivals of the time, King Francis I of France and Emperor Charles V of Hapsburg.

As representative of the Medici family, Clement VII felt closer to Francis; as a matter of fact, however, he never opted clearly for one party or the other, making way for an unnerving political see-saw. When in 1525 Charles subjected Francis to a disastrous defeat in Pavia (even taking him prisoner), Clement officially took sides with the winner, but secretly formed the Holy League with France, England, Florence and Venice. The troops mustered by the Pontiff and by the Serenissima marched into Lombardy against the imperial army. Under the command of Charles III, Duke of Bourbon, the imperial army succeeded in taking Milan and pushing the enemy back towards Lodi. During these maneuvers one of most the valiant captains of the epoch would lose his life: he was none other than Giovanni dalle Bande Nere, member of the secondary branch of the Medici family.

The Sack of Rome and the new Florentine Republic

Charles V then determined to attack the "traitor Pope" head-on, and in 1527, after a dramatic siege, ordered the sack of the Eternal City. The Landsknechts – Lutheran soldiers of fortune from Bavaria and Franconia – abandoned themselves to horrible excesses.

Clement found refuge inside the walls of the Castel Sant'Angelo (boasting among its defenders the great Benvenuto Cellini in the role of gunner); he then managed to escape disguised as a peddler, and made it to Orvieto on December 7. The imperial troops would abandon Rome only after months of death and destruction, when the plague – spreading overnight – started taking its victims among the soldiers as well.

Meanwhile in Florence the Pope's vacillating politics had not met with great favor and, on hearing the news of the Sack of Rome, many Florentines thought that the

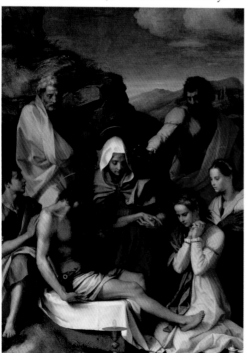

moment had arrived at last to once again banish the Medici from the city.

Ippolito, Alessandro and little Caterina were not the only Medici living in the city. Though not in the house on Via Larga, Clarice, the wife of Filippo Strozzi, daughter of Piero the Unfortunate and Alfonsina Orsini, was also in Florence. She considered it dishonorable that the ancestral palace was occupied by two illegitimates; moreover, as one of the Pope's fierce enemies she could not tolerate Florence's subjection to his natural son. She therefore convinced her husband to take sides with the anti-Medicean party, and on May 19 1527 she took an active part in the revolt that exploded in follow-up to the Sack of Rome and culminated in the ousting of her cousins. Ippolito and Alessandro fled, while Florence, having regained its liberty, named Niccolò Capponi as gonfaloniere. The act was equivalent to a declaration of war on Pope Clement, who was not long in seeking vengeance.

In December of the same year the Pope, who had found shelter in Orvieto, managed to provoke a new conflict between Charles V and Francis I. The latter was allied with England, Venice, Genoa, Ferrara and – in keeping with tradition – Florence. The Republic thus found itself in open opposition to the Emperor and the Pope. In June 1529 the Pontiff met Charles V in Barcelona, where the two negotiated a secret accord: Clement would recognize Charles V's supremacy in Italy by crowning him Emperor – a ceremony due to take place in Bologna the following year. In exchange the Emperor would back the Medici's return to Florence.

The following August the growing threat of Turkish expansion compelled Charles and Francis to draw up the treaty of Cambrai. The King of France agreed – in exchange for Bourgogne – to abandon its allies, withdrawing its troops from imperial territories and renouncing all claims over Italy.

Characterized by its three crescents, the **Strozzi coat-of-arms** decorates the façade of the family palace. Anxious to stay in the Magnificent's good graces, the Strozzi submitted Michelozzo's grandiose plan for their palace to him for advice.

Below: **Moses defends the daughters of Jethro** (Florence, Uffizi). Giovanni Bandini commissioned this Mannerist masterpiece to Rosso Fiorentino (Giovanni Battista di Jacopo, 1494-1540). Counted among Filippo Strozzi's personal friends, Bandini was accused of homicide and forced to flee Florence, where he returned alongside the imperial forces.

Giorgio Vasari and Giovanni Stradano, **Siege on Florence** (Florence, Palazzo Vecchio, Sala di Clemente VII). To the left of the painting, the encampment of the Prince of Orange on the hills overlooking the south-southeast of the city. The glorious final episode of the Florentine Republic was immortalized in a celebrated epic novel by Francesco Domenico Guerrazzi. Born in Livorno, the author was a member of the temporary Tuscan government following the 1859 ousting of the last grand duke, Leopold II of Hapsburg-Lorraine. Below: An elaborately decorated processional shield ("rotella") once belonging to Duke Alessandro de' Medici (Florence, Bargello). Facing page, below: Justus Utens (active 1588-1609), **Villa of Petraia**, detail from lunette on canvas (Florence, Palazzo Pitti, Magazzino del Soffittone). Alessandro confiscated Petraia from the Strozzi around 1532; it later served as the residence of Ferdinando I, and was frescoed by his son, Don Lorenzo.

The heroic defense of 1529-1530

And so Florence found itself alone in confronting the Hapsburg army placed at the Pope's disposal. Led by the Prince of Orange, the imperial troops reached Florence on October 14 1529.

The citizenry was ready to receive them. In preparation for the siege everything within a mile of the city walls had been burnt to the ground: villas, churches, convents, vineyards, trees, gardens – nothing was spared. Michelangelo Buonarroti undertook various tasks for his city's military defense, designing all of the fortifications around the hill of San Miniato, a strategic location for enemy attacks. The population fought valiantly for ten long months of siege. Outside of the walls Francesco Ferrucci, at the head the Florentine army, inflicted more than one defeat upon the enemy, but in the end would have to surrender before the imperials' overwhelming numerical superiority.

One after the other Volterra, Pistoia, Prato, Lastra a Signa and San Miniato al Tedesco fell into enemy hands. In July 1530 the Prince of Orange launched a decisive attack against Ferrucci – the very life and soul of Florentine resistance – who was reconquering lost territory and had even managed to liberate, albeit momentarily, Volterra and San Miniato. The final battle between the imperials and the republicans took place on August 3 at Gavinana, on the Pistoiese mountain range. The Prince of Orange met his death on the battlefield, but the Spaniards' victory was sealed. Ferrucci, already wounded in combat, was captured and finished off by the dagger of Fabrizio Maramaldo, to whom he directed his famous line: "You strike a dead man!"

Before throwing its doors open to the enemy, Florence succeeded in obtaining Clement's promise to leave the current form of government unchanged. The Pontiff also assured the citizens he would be magnanimous with those who had borne arms for the republican cause.

Giorgio Vasari was still a young man when he painted this celebrated portrait of **Alessandro de' Medici** in 1534 (Florence, Uffizi). The Duke is depicted in full armor; he holds a royal scepter in the shape of a weapon; resting on the ground to the left, his visored helmet. The view of Florence in the background has a precise political significance: for the first time a Medici is no longer merely "primus inter pares," or first citizen, but rather the absolute ruler of the state. As notes historian Marcel Brion, "the politics of Alessandro were truly egalitarian, in so far as everyone was subject to the monarch, all endowed with equal rights, or rather equally deprived thereof."

The tiranny of Alessandro

This, however, was not to be. Many of the Medici's adversaries were tortured and killed, others exiled; and it was only to avoid another revolt that the Pope decided to place the city temporarily in the hands of one of his representatives, Baccio Valori. Ten months later, Clement was able to fully implement his plan, and on July 5 1531 his son Alessandro took possession of the palace on Via Larga. Initially he posed as head of the Republic, but in the meantime the Pope had ordered the construction of a fortress – the future Fortezza da Basso –

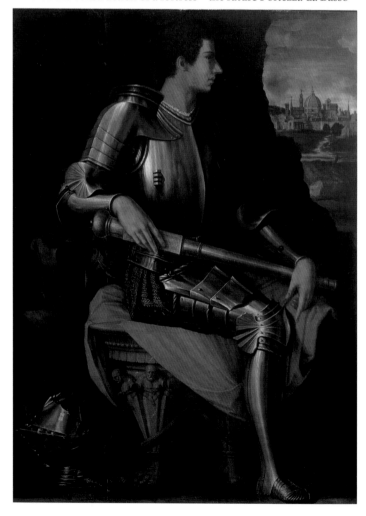

to accommodate the imperial troops that would guarantee the defense of the dynasty. On May 1 1532, the fortress newly-completed, Alessandro assembled the members of the Signoria in his palace, and gave public reading to the Emperor's ordinance dismantling the republican institutions and conferring upon him absolute power.

Having attained his coveted goal, Clement was free to dedicate himself to his intrigues. His final act of "see-saw politics" consisted in the renewal of his ties with Francis I, culminating in the marriage of the young Caterina with the King's second-born son Henry, Duke of Orléans. The wedding, officiated by the Pope himself in the presence of the King of France, took place in October 1533. Clement died on September 25 of the following year, just a few months after the schism promoted by Henry VIII had abstracted England from papal supremacy.

Two irreconcilable cousins

Ippolito and Alessandro had conflicting personalities, and during their younger years passed together in Florence they regarded one another with cordial dislike. After Alessandro's nomination as Duke of Florence their mutual loathing transformed into outright hatred.

Pope Clement tried to placate the disgruntled Ippolito by naming him cardinal. Then, hoping to further solidify the secret pact of Barcelona and also to leave his son in good hands, he arranged the betrothal of Alessandro with Margaret, Charles V's natural daughter. The Duke's position thus seemed impermeable, and not even the Florentines – for all the abuses of power that they expected to suffer by him – seemed inclined to rise up against the Emperor.

Popular tradition paints Alessandro as an arrogant and depraved man, while it speaks of Ippolito as an attractive youth with mild manners. However, behind these appearances there lay a temperament anything but accommodating. Although sent to faraway Hungary by the Pope, the young cardinal had not laid aside his dream of returning to Florence as its ruler. He returned to Rome to care for the ailing Clement, and remained there after his death. The following year some of the exiled Florentines sent an embassy complaining of Alessandro's misdeeds to the Emperor, and Ippolito gladly assumed the role of ambassador. As Charles V was in Tunisia busy with an expedition against Turkish pirates, Ippolito had to embark for Gaeta. However, having reached the nearby vil-

Cardinal Ippolito, Alessandro's cousin and indomitable rival, in a portrait by the school of Bronzino (Florence, Uffizi).

Brutus, by Michelangelo (Florence, Bargello). Permeated by noble dignity and manly resolve, the bust was commissioned by Cardinal Ridolfi with the mediation of Donato Gianotti. Both men were advocates of the anti-Medicean party, and the bust was interpreted as a celebration, through the classical reference, of Alessandro's assassination. Below: The quadrangular base of the **monument to Giovanni dalle Bande Nere**, by Baccio Bandinelli (1488-1560), near the basilica of San Lorenzo. In the scene below Giovanni, in the garb of a Roman commander, receives the act of surrender from his vanquished foes. Here we find another nod to the classical, but from the opposite end of the political spectrum: ordered by Cosimo I, the work is an undisguised celebration of the hereditary monarchy established under his very rule.

lage of Itri, he died suddenly on August 10 1535: it is not known whether the cause was a violent attack of malaria, or rather poisoning by one of Alessandro's henchmen. Whatever the case may be, the cardinal's premature death turned out to be providential for his cousin, who at this point had free rein. Marrying Margaret in the Church of San Lorenzo on June 19 1536, Alessandro appeared solid in the saddle; however, the final turn of events had yet to transpire.

A new Brutus

Ranking among the many figures of dubious fame surrounding the Duke of Florence there was a Medici named Lorenzo, descending from the secondary branch of the family, and thus one of Alessandro's distant cousins.

Born in 1514, Lorenzino ('Little Lorenzo,' as he was known for his minute stature) or Lorenzaccio ('Nasty Lorenzo,' as he would be later re-baptized) had an ambiguous and twisted character. He pretended to be a good friend to Alessandro, becoming his informer and confidant. Actually, it seems that his secret aim was to rise to glory as a born-again Brutus, executioner on behalf of the entire citizen body. To realize his plan – which did not, perhaps, preclude the possibility of taking his cousin's place – Lorenzino decided to exploit Alessandro's well-known penchant for ladies. Among the countless women to attract his attention, there happened to be a relative of Lorenzino's. It might have been his aunt Caterina Ginori, or perhaps his attractive sister Laudomia, Alemanno Salviati's young widow. Lorenzino lived in a house adjacent to the Medici palace, and the rendez-vous was fixed for the night of Epiphany, 1537. But lying in wait for Alessandro would be neither Laudomia nor Caterina, but Lorenzino in the company of a ruffian nicknamed Scoronçoncolo. The Duke, wounded by his cousin's dagger blow, was finished off by Scoronçoncolo with a mortal gash to the throat. The corpse was not discovered until the following day, when Lorenzino was already in Bologna, making his way to Venice.

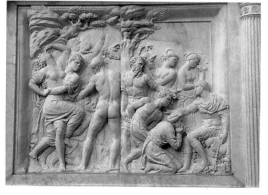

The coming of Cosimo

The gesture was completely futile from the political point of view, as in the uproar following the despot's death the anti-Medicean party proved uncertain and divided. The Palleschi – so-called for the balls, or *palle*, on the Medici coat-of-arms – obviously took advantage of their weakness and elected Cosimo, son of Giovanni dalle Bande Nere, as Alessandro's successor (1537). As his first public act, the new duke condemned Lorenzino, then in Venice, to death. The sentence would be carried out eleven years later: Cosimo's henchmen found the "new Brutus" on the banks of the lagoon, where he fell – with poetic justice – to the dagger. Nor did his death provoke any regret whatsoever in Florence – an indirect demonstration of the fact that the initiative to assassinate Alessandro had been purely personal.

Cosimo's rise to power was a crucial turning point in the history of both his family and Florence: the republican institutions would disappear once and for all, and the family's power would be institutionalized, becoming hereditary – in short, a monarchy was born.

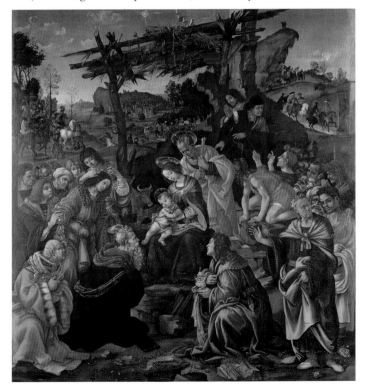

Adoration of the Magi,
by Filippino Lippi (1457-1504).
Various members of the minor
branch of the Medici family
are represented: bottom left,
kneeling, Pier Francesco;
behind him, his sons Lorenzo
and Giovanni, father
of Giovanni dalle Bande Nere
and grandfather to Grand Duke
Cosimo I (Florence, Uffizi).

The family at its pinnacle

As destiny would have it, no direct descendants of Cosimo the Elder or Lorenzo the Magnificent ever assumed absolute power. The privilege fell instead to a member of the minor branch of the Medici family. Born the son of a great mercenary captain, Cosimo became the first grand duke, and completed the transformation of Florence into a regional state. In the meantime a Medici was about to rise, for the first time in history, to the throne of France.

The secondary branch of the Medici family

Before we examine the significance of Cosimo's rule, it is necessary to take a look at the secondary branch of the Medici family: for it is here that the future first grand duke of Tuscany originated. The offshoot stems back to Lorenzo the Elder, son of Giovanni di Bicci and thus brother to the first Cosimo. Although this branch outlived the principal one, several of its members had a difficult existence, marked by hardship and mourning. Here we will provide some examples.

Lorenzo's son, Pier Francesco the Elder, had two sons of his own: Lorenzo (Lorenzino's grandfather) and Giovanni, both referred to as Popolani ('Commoners'). The latter's marriage to Caterina Sforza (1497) was the first truly prestigious union in the history of the Medici. Giovanni, sent by the Republic as ambassador to Forlì, here met Caterina Sforza, Countess of the city and Duchess of Urbino. Just thirty-five years old, Caterina had already put two marriages behind her, both of which cut short by her husbands' violent deaths. She married for the first time in 1477 to Girolamo Riario, one of the protagonists in the Pazzi Conspiracy. Widowed in 1478, she remarried the following year to Giacomo Feo, destined to die during an ambush in 1495. These two unions left her with the sizable inheritance of seven children. Her third

Left: Giovanni, son of Pier Francesco de' Medici, by the school of Bronzino. The portrait faithfully reproduces the model presented in the "Adoration of the Magi" by Filippino Lippi. Lorenzo the Elder's descendants were referred to as "Popolani" (Commoners) for their outspoken democratic sympathies (Florence, Uffizi).

Right: Detail from a portrait of **Caterina Sforza** attributed to Marco Palmezzano (d. 1539). Countess of Forlì and Duchess of Urbino, Caterina's third marriage was to Giovanni the Commoner, a member of the minor branch of the Medici family. But the marriage, arranged in part to reinforce ties between her small state and Florence, was short-lived: Giovanni died at the young age of 32, a few months after the birth of his first and only son. Dispossessed of her dominions and imprisoned by Cesare Borgia, natural son of Pope Alexander VI, Caterina sought refuge in Florence, where she died in 1509. Her son, barely eleven at the time, was raised under the tutelage of Jacopo Salviati. Under the name of **Giovanni dalle Bande Nere**, he would go on to become a great mercenary captain (below, in a portrait from the school of Bronzino, Florence, Uffizi).

marriage, to Giovanni, had a clear political significance. At the time Urbino was surrounded by powerful neighbors – especially the Pope – aspiring to conquer the small duchy. The Commoner not only possessed innate diplomatic skills, but also represented the concrete possibility of an alliance with Florence. The couple had one child: Ludovico was born in April 1498, just a few months before his father died of an illness contracted in Pisa. This husband proved no exception to the Duchess's unfortunate track-record.

Widowed for the third time, Caterina would have to confront alone the unscrupulous Pope Alexander VI, who had resolved to conquer Forlì in order to give it to his son, Cesare Borgia. The papal army captained by his son entered Forlì in early January 1500, and Caterina – who had left her children in Florence and was back in Urbino – was taken prisoner, transported to Rome and locked up in the prison of Castel Sant'Angelo. Here she remained for more than a year until, in a providential intervention, Louis XII of France compelled the terrible Borgia to free her. The Duchess was thus able to return to Florence, where she was greeted by all of her children including the little Ludovico who, upon his father's death, had adopted the name of Giovanni. Warmly welcomed by the Florentines, Caterina passed practically all of her last eight years of life in the villa of Castello, inherited from her last husband. During this time, however, other misfortunes would befall her: her brother-in-law Lorenzo initiated a bitter, inheritance-related battle, even going so far as to kidnap Ludovico-Giovanni, later freed on ransom.

Giovanni dalle Bande Nere

The Duchess died in 1509, outliving her brother-in-law by two years. Eleven-year-old Giovanni remained under the care of his mentor Jacopo Salviati, who, having married Lucrezia (Lorenzo the Magnificent's daughter) was now part of the Medici family. Jacopo hosted him in his

palace on the Corso for six years, until another Giovanni de' Medici, the Magnificent's son, became pope with the name of Leo X. In 1515 the Pontiff summoned the youth, educated in Greek and Latin classics and, though still a boy, already dreaming of military glory. The very next year Giovanni was entrusted with the task of conquering Urbino at

Justus Utens, **Villa of Castello**, detail from lunette painted on canvas (Florence, Museo di Firenze com'era). Located a few miles northwest of Florence, this spacious villa was purchased in 1477 by Lorenzo di Pier Francesco, and later served as home to Caterina Sforza and her son Giovanni. Cosimo, in turn, was raised here by Maria Salviati; once he had turned over the affairs of the state to his son Francesco, he retired to Castello with his second wife Camilla Martelli, and lived there until his death. Below: **Maria Salviati**, by Jacopo Pontormo (Florence, Uffizi). The portrait subscribes to an iconographic model that would later be followed by Giorgio Vasari.

the head of one hundred horsemen. The young leader quickly proved that he was born for the battlefield, earning a fame never destined to fade: he would go down in history as Giovanni dalle Bande Nere, so-called as his soldiers wore a distinctive black sash.

In November 1516 at the age of eighteen Giovanni married Maria Salviati, daughter of his tutor and Lucrezia de' Medici. With this marriage the two branches of the family were reunited, Maria being great-grandniece to Cosimo the Elder, and Giovanni grandnephew to Cosimo's brother, Lorenzo the Elder. The captain became a father on June 12 1519, and his son was given the name of Cosimo in honor of his ancestor, who had been *Pater Patriae*. In 1521, upon the outbreak of hostilities between Francis I and Charles V, Giovanni dalle Bande Nere and his troops marched alongside the imperial forces, confirming his reputation as invincible one day after another. He passed his life moving from one battleground to the next, rarely returning to his wife Maria and his little son in Florence.

With Leo X's death and Clement VII's subsequent election to the papal throne Giovanni remained the only legitimate heir to the House of Medici; but we already know what Clement had in mind for Florence. The Pope did his best to keep Giovanni occupied in battle, thus removing him from the political scene. He probably hoped that the warrior would perish in the course of one of his many campaigns: an unfortunate event that came to pass in 1526. During the battle of Mincio the condottiere was wounded in the knee by an arquebus. The wound was not mortal in itself, but at the time neither the surgical tools nor the bandages were sterilized, and the danger of gangrene lay in

Right: **Cosimo**, in a portrait by the school of Bronzino (Florence, Uffizi). With Cosimo, the first grand duke of Tuscany, the two branches of the Medici family would be reunited.

Below: the **tower of the Trebbio castle**, surrounded by the cypresses typical of Tuscan landscape. It was in this castle, formerly home to his father Giovanni dalle Bande Nere, that Cosimo received the news of Alessandro's assassination and decided to return to Florence to assume command. When he became grand duke he turned the villa over to his son Pietro. In 1645 the entire property was relinquished to the Serragli family.

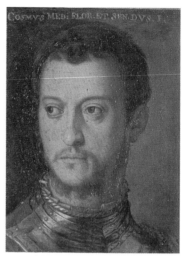

constant ambush. Giovanni's leg was amputated in a vain attempt to save his life, but by then the infection's progress was unstoppable. He died after a few days of agony amidst atrocious suffering. He was buried in Mantua, and it was not until 1685 that his remains were transferred to Florence to rest in the family mausoleum.

Cosimo on the public scene

Maria Salviati was at this point on her own, with a child just seven years old who had to be carefully guarded against Pope Clement and his son Alessandro. In this epoch the Medici could count just two legitimate male heirs: Lorenzino, son of Pier Francesco the Younger, and Cosimo himself. Maria decided to leave Florence, retreating to the castle of Trebbio, in the Mugello, where she lived a secluded life dedicated entirely to the upbringing of her son. She chose to let the Florentines forget all about them; and in fact, when eighteen-year-old Cosimo came forward after Alessandro's assassination in 1537, no one was able to recognize him.

Alessandro's death and Lorenzino's subsequent flight gave momentary rise to hopes for the restoration of the Republic, particularly as the new pope Paul III didn't seem to have any particular designs on Florence. And yet, when Cosimo stood up before the Senate, it was to convince them to ratify his election as duke. He claimed to want to exercise the role in a purely symbolic, representative way, and promised to leave all of the power in the hands of the elected magistrates. Convinced by his humble and retiring manner, the senators – in particular Francesco Guicciardini, Filippo Strozzi, Baccio Valori and Niccolò Acciaiuoli – accommodated his request. Cosimo was named head of the government, with the clause that all of the real power would remain in the hands of the Council. In a skillful move the youngster also managed to convince the senators to promulgate a decree by which Lorenzino's side of the family, sullied irreparably by Alessandro's assassination, lost every right to succession. Little time passed before his four advocates realized the mistake they had made, but by then Cosimo had the reins of power firmly in hand. The Grand Duchy was hence born of deception.

A bloody political debut

Cosimo's name is thus linked above all to the end of the old city order, and to the transformation of Florence's public institutions into a monarchy. One part of the city was opposed to this evolution and not a few illustrious citizens – among which Baccio Valori and Filippo Strozzi, notwithstanding their earlier support for him – chose the path of voluntary exile. The great politician and historian Francesco Guicciardini, on the other hand, retreated to his villa in Arcetri where, between 1537 and 1540, he wrote his *History of Italy*, a careful reconstruction of forty years (1492-1534) considered in the context of European events.

Cosimo's exiled detractors managed to form an army, hoping to oust the "tyrant" and reinstate republican institutions. Mere pipe-dreams: the battle of Montemurlo (August 1 1537) concluded with the crushing victory of Cosimo's army, led by Charles V's general Alessandro Vitelli. Cosimo received full support from the Emperor, who bestowed upon him the title of duke.

Cosimo's revenge was terrible: all of the rebels (including Baccio Valori and Filippo Strozzi) were decapitated. This bloody political debut remained, however, an isolated event: during the course of his reign the first grand duke would prove to be a temperate man and able statesman. Under his guidance Florence and Tuscany regained much of the economic and political stature that had been lost since the death of the Magnificent.

With the victory of Montemurlo Cosimo secured control over Florence on a permanent basis, whereas he managed to extend his hold over all of Tuscany only gradually. A gift to Cosimo from Pope Pius IV, the column of pink granite dominating Piazza Santa Trinita commemorates the victory of the Florentine army in the battle of Marciano (1554), concluding step of the above mentioned process. In 1580 Grand Duke Francesco had Francesco del Tadda's statue of Justice placed on top. Left: **Falcon's hood** in feathers and leather. The ivory support bears the Medici-Toledo insignia (Florence, Bargello).

Marriage and housing

One of Cosimo's first objectives was to arrange a "political marriage," effectively the equivalent to an unwritten pact of alliance with another European state. His choice fell upon Eleonora, the only daughter of the Marquis of Villafranca, Don Pedro de Toledo, Viceroy of Naples and Charles V's lieutenant-governor. A worthy choice, without a doubt, as Eleonora's dowry included illustrious kinship and great riches. The wedding (1539) was celebrated with pomp in the Basilica of San Lorenzo, accompanied by lavish parties and performances.

Cosimo, in the meantime, had decided to move into the Palazzo Vecchio, abandoning the old palace on Via Larga. This act exemplified the young duke's skill: on the one hand, the edifice offered greater protection in the case of future revolts; on the other, it had been the symbol of civic power for more than two centuries. The Medici were no longer *primi inter pares*, a privi-

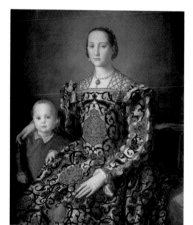

Eleonora de Toledo with her son Giovanni, by Agnolo Allori known as Bronzino (1503-1572). In the portrait, painted around 1544, the first grand duke's lovely Spanish wife wears the stunning bridal gown in which she would one day be buried (Florence, Uffizi). Below, center: the **Crossing of the Red Sea** is part of the fresco cycle with which Bronzino decorated Eleonora's chapel in Palazzo Vecchio.

leged family merely influencing, albeit in a decisive manner, the government from the "private" rooms of Via Larga. They now incarnated power itself.

Cosimo's pro-imperial politics

In 1542 war resumed between Francis I and Charles V. Cosimo, adopting a position compatible with his nuptial politics, abandoned the traditional friendship with France and sided with the Emperor, although with the very recent death of the Dauphin of France another Medici was already destined to become queen of that country. But the Duke's plans involved the gradual conquest of Tuscany overall, an objective feasible only with Charles V's support. During the conflict, not by chance, Cosimo periodically fattened the imperial coffers with generous loans, asking in return the liberation of one Tuscan territory after the next, finally arriving at complete independence. The course of events proved his reasoning sound: with Francis I's death in 1547 Charles V saw his own position further reinforced, and Cosimo, who had always backed him, could not but enjoy the fruits of this alliance. The relationship between Florence and the empire grew even closer the following year, when the Republic of Siena rebelled against the Emperor and placed itself under the protection of Pope Paul III. The Duke offered himself as intermediary, and Charles willingly agreed. Crowned by success, the diplomatic mission brought Cosimo the island of Elba, and therefore Portoferraio, destined to become in a few years the first Tuscan outlet on the Mediterranean.

Separating from the city

In the meantime Cosimo's union with Eleonora was proving to be a prolific one: by 1548 seven children had already been born, and another three would follow. Palazzo Vecchio – structurally inappropriate both from the residential standpoint and that of "princely representation" – no longer met the needs of the ducal family. And so Eleonora de Toledo, evidently upon her

The family at its pinnacle **77**

husband's suggestion, decided to purchase for 9,000 gold florins the palace that the Pitti family had started with great ambitions in 1457, but had never completed. The edifice, still known today as Palazzo Pitti, is found on the far banks of the Arno. It was originally designed by Brunelleschi for Luca Pitti (whom we have encountered among the participants in the conspiracy against Piero the Gouty), whereas construction was initiated by Luca Fancelli; then the Pitti family had to leave the work half-finished due to financial ruin. Since 1470 the palace that Pitti had intended to be the most lavish in the city had been completely abandoned, and only after Eleonora's purchase was it completed according to its original design. By 1550 it was ready, with a rectangular structure (the central section of the building that we see today) and seven windows on three floors. Between 1558 and 1577 it was expanded by Bartolomeo Ammannati with the insertion of two grandiose windows in the lateral doors and the construction of its splendid courtyard.

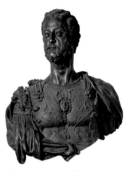

This laurel-crowned bust of **Cosimo**, housed today in the Bargello, was sculpted by Benvenuto Cellini (1500-1571) between 1545 and 1547. The piece apparently did not suit the tastes of the Grand Duke, who in 1557 had the piece moved to the entrance of Forte Stella in Cosmopoli. Below: Justus Utens, **Belveder with Pitti**, detail from lunette painted on canvas (Florence, Museo di Firenze com'era). Built for Luca Pitti in the 1450s, the palace was purchased in 1549 by Eleonora de Toledo, who entrusted its expansion and courtyard design to Bartolomeo Ammannati (1511-1592). The gardens, on the other hand, were designed by Niccolò Pericoli, known as Tribolo (1500-1550).

To this day a magnet for millions of tourists, the new magnificent residence – clearly attesting to the ambitions of the ruling house – distanced the Medici all the more from the citizenry. The Medici's fortunes, particularly under Lorenzo the Magnificent, had always seemed to coincide with those of Florence and its institutions. In Cosimo's age, on the other hand, Palazzo Vecchio became the city's administrative headquarters, and what in Savonarola's day had been the hall where the Republic's General Council convened, now became the court theater. In Lorenzo's epoch the shows and tournaments organized by the Medici took place in the piazzas: now the ruler of Florence enjoyed a private theater, where the spectators were admitted by invitation only.

The privatization of entertainment was but one of many symptoms of the privatization of power. Another might be identified in the construction of the famous "corridor" connecting Palazzo Pitti with Palazzo Vecchio, realized by Giorgio Vasari in record time in 1565. Imperiously crossing houses, towers and churches, this elevated gallery not only constitut-

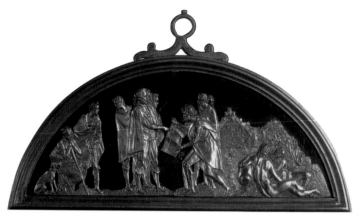

Cesare Targone, **Foundation of Cosmopoli-Portoferraio** (Palazzo Pitti, Museo degli Argenti). The lunette in gold and jasper, realized according to a design by Giambologna, was destined for a cabinet by Buontalenti. The foundation of Cosmopoli (1548-1549) was immortalized by Vasari in a fresco in Palazzo Vecchio. Below: Mirabello Cavalori (1535-1572), **Wool Factory** (Palazzo Vecchio, Francesco's Studiolo). Under Cosimo I's rule, reforms were enacted in the wool sector and tapestry weaving was promoted.

ed an *avant-garde* architectural solution, but was also emblematic of Cosimo's power over the city. The Vasari corridor allowed the Duke to cross the river and part of the city unseen, in complete security, far from the public eye.

What's more, the Boboli Gardens flanking the new ducal residence would become in the course of decades the image of a "city within a city," the juxtaposition between the Ducal Florence, constructed by its master, and the Real Florence, that of the bourgeoisie, of the artisans and working class. Initiated in 1550 at Eleonora de Toledo's request, the garden was completed during the course of the following century. With roads and piazzas, theater and statues, the garden was laid out like a city in miniature, accessible only to the court and its guests: a clear example of nature "educated" by art.

The completion of the regional state

But let's get back to politics. In 1552 Siena rebelled against the Emperor for the second time, and the following year Cosimo decided to intervene – officially in order to return it to Charles V's dominion, but in reality to annex it into his own territory. At this point the Duke could rely on a fairly efficient army, capable of confronting the Sienese troops, that consisted primarily of French soldiers. The war was quite long and the battles devastated the countryside of Siena, the last independent city-state in Tuscany. In the clutches of a siege that decimated the population Siena surrendered only after three years, in April 1555 – formally falling into the hands of Charles V's son Philip II, but actually becoming part of Cosimo's domain. Notwithstanding the merciless cruelty of the war conducted against the Sienese, once he had possession of the city the Duke proved that he could alternate the fist of iron with the velvet glove. He behaved as a magnanimous and open ruler, imposing few changes and respecting the local habits and customs. As proof of this remains the fact the Siena would never rebel against Medicean rule, demonstrating loyal-

ty and even gratitude to Florence. With the territories acquired earlier and the conquest of Siena, Cosimo found himself at the head of a regional state, and the relative calm reigning in Italy allowed him to dedicate himself to the administration of his domain and to its economic growth. As noted earlier, Tuscany under his rule enjoyed a remarkable increase in terms of wealth and political importance, especially when compared to the condition of the other states on the peninsula. For the first time reclamation works were initiated in the Sienese Maremma, and Pisa, Piombino and Livorno were fortified.

The latter, in particular, would eventually assume a strategic role from both the military and the economic standpoint. Moreover, mining and quarrying activities were intensified, and the increased exploitation of the marble caves in Carrara gave Tuscany another active item in the commercial balance abroad.

In the meantime Cosimo did not neglect the embellishment of his own residence, managing to buy back many of the works of art lost during the sackings of his mansion in 1494 and 1527. Archeological excavations ordered by Cosimo shed new light on the ancient Etruscan settlements. Moreover, his great passion for botany led him to create the Giardino dei Semplici in Florence and the Botanical Gardens in Pisa. The University of Pisa also flourished under his tutelage.

Shield with the battle of Scannagallo, also known as the "Rotella Odescalchi," by Giovanni Stradano (Rome, Palazzo Venezia). The painting on the processional shield depicts the Florentine troops under the command of the Marquis of Marignano defeating the Sienese near Marciano, in the Val di Chiana. Medicean ownership of the shield was established only recently, thanks to the presence of the yellow standard bearing the Marquis' emblem, a two-headed eagle.

A long series of familial losses

The good fortune that seemed to accompany each of Cosimo's political enterprises did not prove equally generous with his family members, many of whom disappeared at a young age.

Of the ten children born to Eleonora de Toledo, only five would live to celebrate their twentieth birthday. In 1562 Eleonora herself died at the age of forty, along with her children Giovanni and Garzia: they were done in by malaria contracted during their travels in the Maremma. It was a terrible blow for the Duke, and not just from the sentimental standpoint. Many of his political plans had gravitated around Giovanni, made

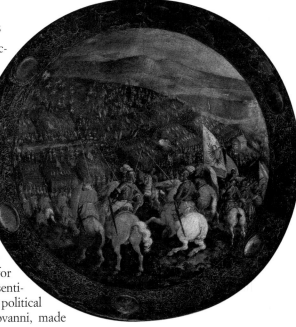

Right: Chalcedony cameo depicting **Cosimo's triumphant entry into Siena**. In accordance with a convention already seen in other examples, the Duke is portrayed in the attire of a Roman "imperator" (Florence, Palazzo Pitti, Museo degli Argenti).

Below: **Don Garzia de' Medici** as a child, in a portrait by the school of Bronzino (Florence, Uffizi). The sudden deaths of Giovanni and Garzia provoked rumors and speculation. It was suggested among other things that Cosimo had murdered Giovanni for having wounded his brother to death in an outburst of rage, and that Eleonora had consequently died of a broken heart.

cardinal by Pius IV two years earlier. For Cosimo this nomination had meant getting one step closer to the Papal State and to the Pope, by whom he was hoping to be consecrated as Tuscan sovereign. In effect, he was still formally a vassal to Emperor Ferdinand I, who did not appear at all willing to dub him king or grand duke. A papal appointment bore the same authority as an imperial one, and Cosimo was well aware that it was easier to have sway in Rome than in Germany. Now, Giovanni's demise made it unquestionably more difficult to reach his coveted objective. With Eleonora's death, in Palazzo Pitti there remained just Cosimo and his children Francesco, Isabella (already married to Paolo Giordano Orsini but back in Florence after her mother's death), Ferdinando and Pietro. Maria, the first-born, had died at the age of seventeen in 1557; Lucrezia, married off to the Duke of Ferrara Alfonso II, died in 1561 at the age of twenty-one; to say nothing of Pedricco, who died just one year old in 1547, and Anna, taken after just a few months of life in 1553. In fact, practically all of the future Medici offspring would suffer from delicate health – one of the determining factors in the extinction of the house.

Francesco's marriage and the grand-ducal title

At this point Cosimo's hopes all centered around the ecclesiastical career of the only male child remaining to him other than his heir Francesco: Ferdinando, born in 1549, received the cardinalate from Pius IV in 1563. It was another step closer to Cosimo's nomination as Grand Duke of Tuscany, and two years later he would be even nearer to his goal. Emperor Ferdinand I having died in 1564, Cosimo arranged a marriage with his successor Maximilian II: his son Francesco would marry the Archduchess Joanna of Hapsburg, daughter of Ferdinand I and Maximilian's sister. As usual the wedding was celebrated in San Lorenzo in the beginning of 1565, and the couple chose Palazzo Vecchio for their residence, newly renovated and frescoed for the occasion.

The Pope died in the course of the same year. Pius V ascended to the papal throne, from whom Cosimo expected complete trust and, moreover, the coveted investiture. In 1570 the great opportunity presented itself, as all eyes were turned towards Northern Europe rather than the Italian states. Emperor Maximilian was still in the midst of

Justus Utens, **Villa of Colle Salvetti**, detail of lunette painted on canvas (Florence, Museo di Firenze com'era). Not far from the Tyrrhenian coastline, the villa was built on one of the low Pisan hills and dominated a vast plain overlooking the sea. Around 1571 the property was conceded to Eleonora de Toledo in perpetuity. Below, left: Alessandro Allori (1535-1607) was responsible for this portrait of **Joanna of Austria** (Florence, Palazzo Pitti, Museo degli Argenti), which would serve as a model for numerous portraits of the Grand Duchess.

conflicts between Catholics and Protestants, as was France; the Spanish monarch was warring against the Netherlands and England, the latter hoping to take advantage of the dramatic situation in France to extend its dominion across the Channel.

Amidst this general confusion the Pope published the bull conferring the title of Grand Duke of Tuscany on Cosimo, and the solemn coronation took place in Rome in February 1570. True to Cosimo's own predictions, France and England recognized him at once, while Germany and Spain, although not acknowledging the Pontiff's decree, did nothing to reinstate the *status quo*.

Private matters in Cosimo's last years

After Francesco's marriage the new grand duke – finally satisfied – turned the majority of internal affairs over to his son, and retreated increasingly into his private life in the halls of Palazzo Pitti. Around 1571 he remarried to Camilla Martelli, a Florentine of humble origins who, three years earlier, had born him a daughter named Virginia. Cosimo's children stubbornly refused to recognize Camilla as his legitimate consort, considering the match devoid of legal standing. Cosimo was recidivous: in 1567 Leonora degli Albizzi had born him another son, Giovanni – future architect, scientist, scholar and artillery engineer – who would die in Venice in 1621.

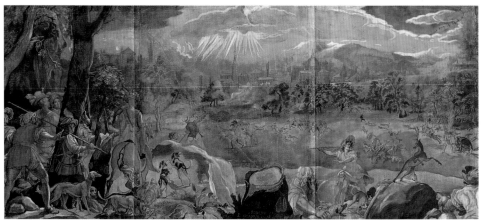

Celebrated in 1565, Francesco and Joanna's wedding was accompanied by all manner of festivities. Federico Zuccari (ca.1540 -1609) prepared this **Deer Hunt** for the stage curtain of the "Cofanaria," a play by Francesco d'Ambra (Florence, Uffizi, Gabinetto Disegni e Stampe). Below: In 1553 excavations promoted by Cosimo near Arezzo unearthed the famous **Chimera** (5th-4th century BC).

Virginia, on her part, married Cesare of Este and died in 1615. Like all nobility, the Medici never lacked illegitimate children; up until now, however, it had never happened that a mistress be made wife. This explains the scorn that greeted Cosimo's gesture: he, in turn, abandoned public affairs altogether and retired with his new companion to the villa of Castello. He died on April 21 1574, leaving Francesco with a profoundly altered Tuscany. From a small republic financially devastated by war Florence had become the capital of a fairly rich and well-administered regional state; an achievement particularly impressive if one considers that in this period, Italy overall was experiencing a progressive economic and political decline.

Caterina, Queen of France

Before discussing Francesco's reign, it is worth taking a step back to look at Caterina, one of the great figures in the history of the Medici.

As we have seen, the young woman – a member of the family's principal branch – was married in 1533 to the King of France's second-born. The evaluation of her tenure as Queen of France was long controversial, doubtless colored by French prejudice against a bourgeois rising to the throne. In fact, the "Italian" ruled during the difficult period of the Wars of Religion that would bloody the country for decades and in which she would reluctantly play the role of protagonist.

Caterina passed her childhood between Florence and Rome, secluded in convents in keeping with the will of her uncle Giulio – the future Clement VII – who intended to keep her far from power. In these cloistered years, however, she did not lack an education: on the contrary the girl precociously achieved a remarkable level of culture. In 1533 Pope Clement arranged with Francis I the marriage of his

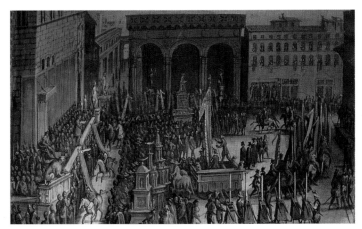

Giovanni Stradano, **Rendering of Homage in Piazza della Signoria** (Palazzo Vecchio, Quartiere di Eleonora, Sala di Gualdrada). In grand-ducal times the celebration, already portrayed on the 15th-century chest conserved in the Bargello (see page 15), was moved to the front of the Palazzo della Signoria, known as "Palazzo Vecchio" (Old Palace) after the Medici family – with the exception of Joanna of Austria and Francesco – had moved into Palazzo Pitti.

Below: **Caterina de' Medici** in a cameo of onyx, gold and rubies (Florence, Palazzo Pitti, Museo degli Argenti). The Queen wears an amulet bearing the symbol of the order of St. Michael, of which Francis had been Grand Master.

niece with the King's second-born Henry of Orléans, and on October 28 of the same year he personally presided over the wedding in the cathedral of Marseille. Caterina was only fourteen years old: just a girl from our perspective, but then marriages at this age were commonplace among the aristocracy of the times.

The "Italian" in court

From the moment of her arrival the climate in the transalpine court was one of diffidence, if not outright hostility. In popular quarters she was seen as an emissary of the Pope, while the nobility could scarcely tolerate the presence of a mere bourgeois. And yet Henry's young wife shined for her physical and intellectual qualities. She was bright, cultured and lively, but she also proved to be an able equestrian and did not disdain hunting. Francis I, impeccable horseman as well as a lover of literature and the arts, was pleased to have such a gifted daughter-in-law; on the contrary Henry, aware that his wife outdid him in every respect, began to nurture a jealousy of her bordering on aversion.

When Francis I's first-born died in August 1536, some conjectured that "Madame Serpent" (as Caterina was spitefully referred to) had had her brother-in-law poisoned in order to guarantee the throne to her husband. The King continued to demonstrate his liking and solidarity, but the malicious rumors did not abate: far from it. To further muddy the waters, Diane of Poitiers (the Seneschal of Normandy's lovely widow) had conquered Henry's heart, and in 1542 urged Francis to convince his son to forsake his reputedly sterile wife. The King did not consent, and the fol-

Jacopo Chimenti known as Empoli (1551-1640), **Wedding of Caterina de' Medici and Henry of Orléans** (Florence, Uffizi). The union of the fourteen-year-old Medici bride and the future King of France was celebrated in Marseille on October 28 1533. Not surprisingly, the ceremony was officiated by Pope Clement VII.

lowing year, as if to spite her husband's lover, Caterina gave birth to the first of no less than ten children, three of which would die during their first years of life. Of the others, three – Francis, Charles and Henry – would ascend in turn to the throne of France, while the daughters would marry the most powerful sovereigns in Europe.

Francis I died in 1547, and his son became King of France with the name of Henry II. His ascent to the throne allowed him to accept his lover, who became *de facto* queen, into the court, while Caterina was completely marginalized. Henry's senior by some twenty years, Diane wielded an influence over him that bordered on subjugation: the King made her the richest woman in the kingdom, while Caterina was sequestered in the gloomy castle of Chaumont. For twelve years the young Florentine lived isolated and offended; but it was perhaps in this period that she developed the strength of character that her contemporaries would speak so highly of. The Venetian ambassadors to the court of France described her as gifted with extraordinary self-control, consenting her to mask her true objectives and feelings; naturally, this subtle diplomatic skill was characterized by her detractors as icy falseness and 'masculine' rigidity.

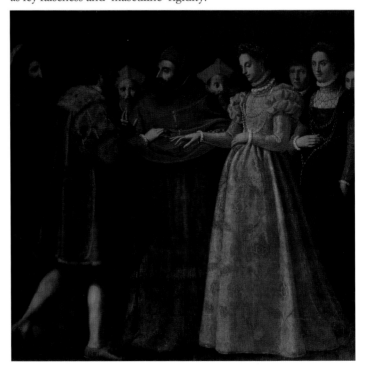

Caterina emerges from the shadows. The death of Henry II

During her long and humiliating exile in Chaumont, Caterina dedicated her attention to the upbringing of her children, awaiting the moment to emerge from the shadows and put her talents to good use. The opportunity arose in August 1557, when the French troops were reeling from a heavy defeat in Saint-Quentin against the army of Emmanuel Philibert, Duke of Savoy. With Henry II occupied in Champagne and panic spreading in Paris – to the point that many fled from the city – Caterina approached the Parliament, and managed to secure the allocation of an enormous sum for the defense of the city and of the nation. Her dramatic and incisive appeal inspired enormous admiration among the parliament members: perhaps for the first time they saw behind the glacial façade a true queen, ready to do anything for her adopted land. Even Henry was struck by his wife's determination, and from that point on his attitude towards her would remain considerably more respectful.

This event, at any rate, did not distract the Queen from her child-rearing responsibilities. On the contrary, she wound up caring for the children of others as well, raising the Queen of Scotland Mary Stuart, who arrived in the French court at the age of five. In 1558 Caterina married the girl to her first-born Francis. The following year her oldest daughter Elisabeth married Philip II of Spain, and the King's sister, Marguerite, married Emmanuel Philibert, Duke of Savoy. The festivities lasted for several days between concerts, shows and banquets, culminating with a grand tournament in which Henry II himself participated. It was during this very joust that the lance of an adversary struck the sallet on the King's helmet: the wooden point shattered and a thick splinter penetrated the sovereign's eye. He died after ten days of agony, leaving Caterina a widow at the age of forty.

The first regency

Naturally, one of Caterina's first acts as queen was the ousting of Diane of Poitiers from the court – indeed a lenient measure under the circumstances.

The year was 1559. Henry's first-born Francis assumed the throne, but by virtue of his young age his mother remained at his side as queen. Caterina would help him make his first moves, a truly arduous task in a France already torn to shreds by the conflict between the Catholics and the Huguenots (from the German *Eidgenossen*, 'confederates'), as the French called the Protestants of Calvinist confession. Mother and son had to cope with the overwhelming power of the Dukes of Guise, leaders of

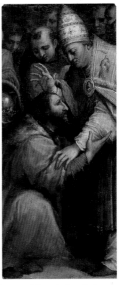

In one of the paintings that decorate the vaulted ceiling of Palazzo Vecchio Giorgio Vasari depicts the encounter between Pope Clement VII and Francis I, King of France, during which the marriage of Caterina and Henry was arranged.

Below: The lid of this precious crystal vase crafted by Gasparo Miseroni for the royal wedding of 1533 bears the interlocking initials of bride and groom (HC). The form of the handle, however, refers to the classic "inconvenient third party," in this case the lovely Diane of Poitiers, the future monarch's lover: the crescent moon scythe is the symbol of the hunting goddess (Palazzo Pitti, Museo degli Argenti).

Details from the portraits of **Henry II** and **Caterina de' Medici** (Florence, Palazzo Pitti, Palatine Gallery), by court painter François Clouet (d. 1572). The paintings probably reached Florence as part of the inheritance left by Christine of Lorraine. Caterina and Henry's marriage was anything but a happy one: when the Duke of Orléans ascended the throne, Diane of Poitiers became queen "de facto," the young Medici bride virtually exiled in the gloomy castle of Chaumont. Nevertheless, she proved her mettle in 1557 when, after the defeat in the Battle of Saint-Quentin, she convinced the Parisian parliament to allocate substantial funds to aid the nation in danger.

the Catholic faction, that held the country's principal public offices. On the religious question Caterina tried to remain equidistant from the two parties; but the Guises, wielding an influence over the young King decidedly superior to that of his mother, declared themselves to be open enemies of the Protestants, who would be ferociously persecuted by them and by other families from the Catholic nobility. However, many people had converted to Protestantism, and the persecution of the Guises could not prevent the diffusion of the reformed creed, especially strong among the middle classes.

Throughout 1560 France was bloodied by the summary executions of the Huguenots, and it was only with Francis II's premature death, which came to pass on December 5 of that year, that one began to see some glimmers of change.

The second regency. France in tempest

As second-born Charles was just ten years old when he took the throne Caterina again assumed the regency, and made at once an important decision: on February 28 1561 an edict was passed proclaiming the end of religious warfare, the freedom of cult and the liberation of all incarcerated Protestants. Quite naturally the Catholics saw the Queen's action as treacherous, and in fact would never forgive her. Some commentators have accused Caterina of duplicity for that very neutrality which during the conflict led her to favor now the Huguenots, now the Catholics, in a desperate attempt to stop the civil war. On the contrary, such behavior reflects a modern political sensibility based on the conviction that the unity of the State transcends the religious preference of its members: the primary task of a monarch is that of furthering peace and coexistence among various cults.

In the meantime the other European sovereigns – the King of Spain, Queen Elizabeth I of England and, not lastly, the Pope – watched the French events unfold, ready to enter into the conflict under the pretext of helping one side or the other, but in reality with the hope of taking control of the kingdom or, at least, of weakening it. What's more, civil war was once again at the doorstep, and all of Caterina's efforts to control the two parties turned out to be in vain. The new conflict erupted in May 1562, following the publication of the royal edict that officially recognized Protestantism, allowing the Huguenots to erect places of worship. The Duke of Guise occupied Paris in the name of Catholics; the Queen and the young King were taken prisoner; civil war spread throughout the country and the English troops arriving to help the Protestants occupied Le Havre and Rouen. A ceasefire would not be reached until February of the following year when, following the assassination of the Duke of Gui-

se, Caterina succeeded in obtaining a declaration of peace and obedience to the edict of 1562 from the heads of the opposing factions. At this point the Queen was able to arm a battalion – composed of Catholics and Protestants – in order to oust the English invaders. The campaign, followed closely by Caterina, concluded with a victory as unexpected as it was rich in symbolic value: people who had fought among themselves up until the day before marched united under the banner of France.

Charles IX on the throne. A political marriage

Unfortunately, the seeds of hatred, once sown, readily regerminate. In September 1567, the hostilities were rekindled, interrupted temporarily in March of the following year. To understand the pressure the Queen was under in this period, it suffices to cite an excerpt from Giovanni Correr, Venetian ambassador to the French court: "I don't know what prince would not have committed some errors in such confusion; and all the more so a woman, a foreigner, lacking trusted friends, frightened, and without ever having a person around to tell her the truth. For my part, I am often amazed that she didn't completely lose her head, giving in to one or the other of the two parties; which would have been a true calamity for the kingdom. It is to her credit alone if today one still finds in this country the vestiges of royal majesty. For this reason, I have always felt sorry for her rather than criticized her; and she has often reminded me of this, in speaking to me of her anxiety and of the ills of France."

In August 1568 the conflict not only erupted anew, but even spread into other countries; the Protestant princes of Germany backed the Huguenots, while the King of Spain sent an army to fight alongside the Catholics. Bereavement, destruction and retaliation followed one after the other in a desperate country, where peace appeared a chimera. Caterina was not able to halt the hostilities until August 1570, although still under conditions that satisfied neither of the two sides. She therefore played a different card: while her son Charles became king under the name of Charles IX, she arranged the marriage between her daughter Margaret and Henry of Navarre, son of the Protestant Jeanne d'Albret. With this union – in itself almost miraculous – she hoped that the opposing factions, brought together by this "mixed marriage," would resolve to lay down arms once and for all. But the consequences were just the opposite of those desired: the majority of the Catholic nobility refused to

Cameo by Gasparo Miseroni (Florence, Palazzo Pitti, Museo degli Argenti) bearing the profile of **Philip II of Spain**. Philip was Charles V's son, and also the consort of Caterina's daughter, Elisabeth.

Below: Jean Clouet (1485-1540), **Claude of Lorraine, Duke of Guise** (Florence, Palazzo Pitti, Palatine Gallery). Leaders of the Catholic League, the Guises were staunch adversaries of the Valois. In May 1562 they managed to seize Paris, imprisoning Caterina and her second-born, the eleven-years-old King Charles IX.

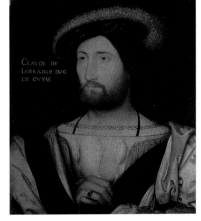

CLAVDE DE
LORRAINE DVC
DE GVYSE

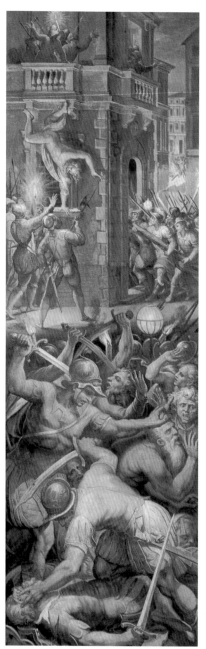

recognize the union, and the embers that smoldered under the ashes burst into flame just after the wedding ceremony (August 18 1572).

The Massacre of St. Bartholomew's Day. Henry III

In the early morning hours of St. Bartholomew's Day (August 24) the Guise-led Parisian Catholics launched a surprise attack and massacred in their sleep a hundred Huguenots who had gathered in Paris for the wedding. The Protestants lay all of the blame for the slaughter on Caterina, even going so far as to say that she had ordered it in full accordance with her son. No documentation exists, however, to support this hypothesis, formulated immediately after the slaughter. For their part the Catholics did not contradict their adversaries, only too happy to cover their tracks with the name of the Queen Mother.

The predictable outcome of the massacre was the reprisal of war, the fourth, that lasted a year and was broken by the peace of La Rochelle (June 1573). The treaty reaffirmed the terms of the edict Caterina had promulgated some years earlier. A new conflict commenced the following year and lasted until 1578; the ceasefires that punctuated this period served only to reorganize the warriors. In the meantime Charles IX had died, and had been succeeded to the throne by his brother, who had adopted the name of Henry III. Although Caterina favored him above all her other children, he soon demonstrated his complete incompetence. Extravagant to the point of madness, he left the entire burden of the state in his mother's hands, who would succeed yet again in obtaining a year-long ceasefire. The Queen Mother was now seventy years old: weary and considerably overweight, she continued to pursue her dream of a lasting peace. However, her efforts proved once again to be in vain: France was mired in endemic conflicts, the last of which would destabilize the throne.

As mentioned, the Guises had been trying for some time to overthrow the King in order to substitute their own family for that of the Valois: in May 1588 their army entered Paris, forcing the royal family to barri-

cade itself in the castle of the Louvre. Once again the indomitable Caterina found a way to defuse the conflict, but she had not banked on the unforeseen initiative of her son. Unbeknownst to his mother, on December 23 Henry III had the Duke of Guise assassinated in the royal bedroom of the castle of Blois. Immediately thereafter, he entered his ailing mother's suite to bring her the tidings.

Caterina's death. The balance of a kingdom

Dismayed, Caterina tried to make her son understand the grave consequences that could result from his action, as ferocious as it was impulsive. The elderly Queen tried to avert the worst, but on January 5 1589 her tired heart stopped beating for good. With Caterina expired the principal branch of the Medici family.

Caterina's tempestuous tenure on the French throne was rich with developments that, although seemingly minor, were anything but irrelevant from the standpoint of customs. Caterina introduced great novelties into the French court, bringing from Florence a remarkable cultural legacy. Just a couple of years after marrying Henry, she summoned a veritable legion of Italian artists to her side, and in no time the castle of Fontainebleau was filled with works by Michelangelo, Bronzino, Raphael and Andrea del Sarto. A skilled horseback rider, she is credited with the invention of a saddle destined to revolutionize female equitation. And what about her love for fine cuisine, born in the convent of Le Murate in Florence? As well as bringing a host of chefs from Florence, she often cooked for herself, and some of her recipes earned a permanent place in French cuisine. In terms of etiquette Caterina effected a veritable revolution introducing the use of the fork. She also left France with a considerable legacy in the art of perfumery: the perfumists who had arrived with her from Florence, in fact, worked under her careful supervision.

All things considered, in respect of culture, elegance and political ability Cosimo the Elder's last descendent was worthy of his name.

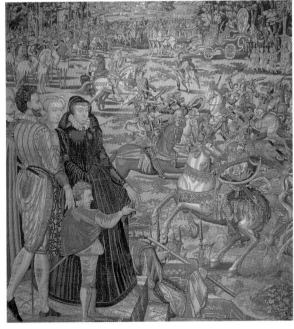

Facing: **Charles IX orders the Slaughter of the Huguenots**, detail (Rome, Vatican Palaces, Sala Regia). In this fresco Giorgio Vasari immortalizes what was undoubtedly the darkest hour of the bloody and ill-famed Wars of Religion. Below: The series of tapestries known as **Celebrations of the Valois**, a gift Caterina was presented with in 1585 by the Flemish ambassadors in Paris. The Queen probably had them shipped to Florence as a present for her granddaughter, Christine of Lorraine, upon her engagement to Ferdinando de' Medici. In the scene below the Queen watches a joust with her daughter Margaret and Henry of Navarre, future King of France (Florence, Uffizi).

Love and death in the house of Medici

*The Medici's legacy of power was not without its romance
and untimely deaths. Francesco and Bianca Cappello,
lovers first and later wed, were probably poisoned;
Cosimo I's daughter-in-law, the second Eleonora de Toledo,
was slain by her violent and jealous husband, Pietro. The Duke
of Bracciano, infatuated with another woman, arranged to have
his wife Isabella, hanged by hired assassins...*

Love at first sight

Francesco's first decision as grand duke involved a family matter: he
had his stepmother, Camilla Martelli, closed in the convent of Le
Murate. The woman was distraught, but the provision came as no
surprise: she was not oblivious to the hard feelings that her stepchil-
dren bore her. It was only after his brother's death that Ferdinando,
assuming the throne, permitted her to leave the Murate to move in-
to the Lappeggi villa. However, tried by years of semi-reclusion in
the convent, Camilla soon showed signs of mental
instability, to the point that Ferdinando was
forced to lock her up anew, this time in the
Convent of Santa Monica. Here she died in
1590 at the age of just forty-five.

Francesco's cruelty to his father's second
wife is all the more striking if one considers
his own private life. Even before his mar-
riage to Joanna of Hapsburg he had a lover
of his own: the young Venetian noblewoman
Bianca Cappello. She had arrived in Florence
just a few years before meeting France-
sco, in pursuit of a tempestuous
love affair that we will here
describe in brief.

Around 1560 Bianca
met a certain Piero Bo-
naventuri, a young Flo-
rentine then working

Sculpted in 1577 by Giovanni
Bandini (1540-1599), this
bust of Grand Duke **Francesco**
crowns the "Porta delle
Suppliche" (Gate of Clemency),
under the arch connecting
the Uffizi courtyard with
Via Lambertesca.

Facing page, left: **Don Antonio**, Bianca Cappello's presumed son, immortalized on a medallion by Antonio Selvi (Florence, Palazzo Martelli). The Grand Duchess underwent sterility treatment of every kind, but probably to no avail. It is said that for this reason she simulated the pregnancy and birth of little Antonio, his real mother being in fact a woman of humble extraction. Below: A portrait of **Bianca**, oil on copper, by Alessandro Allori, a student of Bronzino's. The other side depicts the "Dream of Human Life," an allusion to the redemption one may find in love, modeled on a sketch by Michelangelo (Florence, Uffizi).

on the lagoon at the Venetian branch of the Salviati bank. The two fell hopelessly in love – hopelessly, because Bianca's parents would never consent to a union that would compromise the Cappello family name. Their love, however, was relentless, driving them to marry in secret and then escape to Florence. According to Venetian law Piero risked the death penalty for having kidnapped a noblewoman, while Bianca would have been placed in a convent. Once in Florence the two were forced to remain in hiding, as Bianca's father, Bartolomeo Cappello, had placed an enormous bounty on Piero's head. Bianca passed her days in her husband's modest dwelling located in front of the Church of San Marco. It was here – it seems – that in 1563 Francesco first caught sight of her gazing out the window. The future grand duke's heart was profoundly touched by young woman's beauty, and it was love at first sight. Thus commenced a romance that, before long, would be the talk of the town.

Joanna's useless protests

Strangely enough, Piero, who had risked so much in running off with Bianca, didn't seem too troubled by her infidelity. Perhaps he even nurtured some idea of profiting from the situation. For her part, Bianca had had enough of the reclusive life; nor would the walls of a

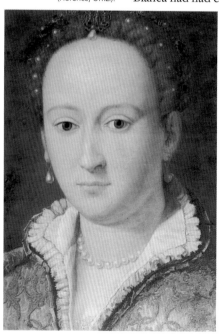

Venetian convent have been more welcoming than the shabby rooms in which she passed her time. She thus saw in Francesco an ideal lover, ready to satisfy her every desire, as well as a perfect safe-conduct – a man who could furnish her with the luxurious lifestyle to which she had been accustomed by her family.

Bianca's affair with Francesco survived his marriage completely unscathed. It didn't take long for Joanna of Hapsburg to take note of the situation, particularly as her husband had placed Bianca among Palazzo Pitti's ladies of honor, housing her in an elegant palace on Via Maggio. Joanna was hard-pressed to compete with the Venetian. Lacking any physical appeal, Emperor Maximilian's sister had, moreover, a cold and unpleasant character. Bianca, in contrast, was gifted not only with great natural charm, but also with a statuesque beauty, underlined by the grace of her features and by her dense, golden locks. Joanna tried to fight back, first seeking support from her father-in-law, Cosimo, who in her opinion should

have intervened to end her husband's extramarital affair. When the Grand Duke died, she brought her grievances directly to her imperial brother. In both cases, however, her entreaties fell on deaf ears.

Francesco's second marriage

In 1572 Piero Bonaventuri died not far from the bridge of Santa Trìnita, killed in an impromptu duel with a youngster he had offended. At that point Francesco was already father to three daughters – Eleonora, Anna and Lucrezia – with two others having died in infancy. From his marriage would follow Maria (1573) and finally Filippo (1577), legitimate heir to the throne. In 1578 an event left the Grand Duke an open playing field: Joanna passed away at the young age of thirty. A short time thereafter Francesco and Bianca's wedding was celebrated secretly in the chapel of Palazzo Vecchio: he did not make the public announcement until June 1579.

Unlike the union between Cosimo I and Camilla Martelli, in which the Duke's second wife was completely disenfranchised and denied all inheritance rights, the marriage between Francesco and Bianca was legitimate and official. As proof, one need only recall the festivities that accompanied the wedding's "public version," with various tournaments, jousts and shows. On October 12 1579 Bianca was crowned in Palazzo Vecchio as Grand Duchess of Tuscany in the presence of the Venetian ambassador. Her new status would inspire the hatred of her brother-in-law Ferdinando, as well as that of many Florentines, who considered her Francesco's evil advisor. When Filippo died at the age of five in 1582, leaving the Grand Duke heirless, many conjectured that he was poisoned by the Venetian, to whom many other crimes had been attributed in various occasions. No documentation exists to verify these rumors which, on the contrary, were belied by Bianca's modest and reserved behavior: she was reluctant to appear in public and much more inclined to pass most of her time in the quiet of the Poggio a Caiano villa.

Eleonora's tragic end

Prior to Francesco and Bianca's wedding, two authentic crimes were committed in the House of Medici. In the August of 1576 Palazzo Pitti was inhabited by the Grand Duke with his wife Joanna, their children and two of Francesco's siblings, Pietro and Isabella. As we

Justus Utens, **Villa of Marignolle**, detail of lunette painted on canvas (Florence, Museo di Firenze com'era). Confiscated from the Ridolfi following the Pucci's conspiracy against Cosimo I, the villa was given to Don Antonio by Francesco, who had also legitimated him.

Below: The statue of **Abundance** (Florence, Boboli Gardens). Conceived by Giambologna (Jean de Boulogne, 1524-1608) as a portrait of Joanna of Austria, the statue was completed in 1636 by Pietro Tacca. The inscription on its base, ordered by Ferdinando II, alludes to the prosperity brought about by Medicean rule.

Many artists contributed to the astonishing sculptures and fountains gracing the gardens of the Castello Villa. Among them Tribolo, who, along with Vasari and Buontalenti, gave form to Benedetto Varchi's iconographic conception. Above: **The Animal Grotto**.

have mentioned earlier, Isabella was married to Paolo Giordano Orsini, Prince of Bracciano, but she returned to Florence after the death of her mother, Eleonora de Toledo, while her husband remained in their home in Lazio.

At the age of twenty-two Pietro had married the daughter of his maternal aunt, named Eleonora like his mother. Raised in Palazzo Pitti after her mother's death, the new Eleonora de Toledo had grown quite close to her cousin Isabella. We can safely assume that Eleonora greeted the news of her arranged marriage with little enthusiasm: Cosimo's last son had demonstrated a spoiled and domineering character since childhood. In fact, their union – from which in the same 1576 would be born the little Cosimo, who died a few months later – was not exactly a happy one: Pietro caused Eleonora considerable suffering, not showing her the least regard. And so, this neglected and bitter wife fell in love with the young Bernardino Antinori, who a short time later would stain his family name with the homicide (albeit in self-defense) of another nobleman, Francesco Ginori. Hoping for Francesco's clemency Bernardino confessed to the crime and was exiled to the island of Elba, from which he sent various love letters to Eleonora. One of these letters fell into hostile hands and would turn

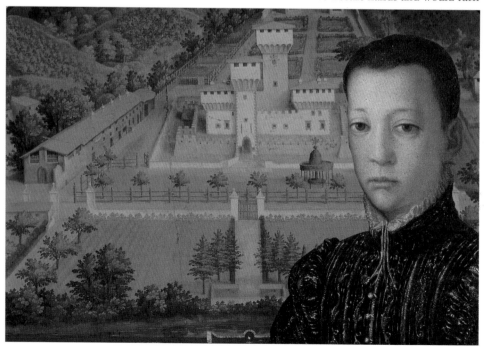

up on the Grand Duke's desk. In order to vindicate his brother's honor Francesco condemned him to death. The sentence was carried out in the Bargello prisons on June 20 1576, leaving Eleonora in the deepest depression. On July 11 Pietro summoned his wife to the villa of Cafaggiolo and killed her, probably with his sword. Officially the family maintained that Eleonora's death was the result of a heart attack, and, to render the story more plausible, she was buried in San Lorenzo alongside the other family members. Subsequent to this bloody deed Pietro was sent by Francesco to the Spanish Court, where he remained until his death in 1604.

The hidden noose

A few days after Eleonora's disappearance a new assassination – this one more clear in its mechanism – would leave the grand-ducal family in mourning. The episode is mentioned briefly in Stendhal's *Italian Chronicles*; the novelist however seems to think that the second murder as well was due to infidelity, and therefore was probably confusing the two events.

Even after her father Cosimo I's second marriage Isabella had preferred to remain in Florence. Her marriage, too, had turned out be an unhappy one: an attractive and intelligent woman, her husband Paolo Giordano Orsini was much older than she was, and treated her in a tyrannical and cruel fashion. The long-distance marriage turned out to be more tolerable not only for Isabella, who thus escaped her husband's oppression, but also for Orsini himself, who had fallen in love with Roman noblewoman Vittoria Accoramboni. It seems that the relationship stemmed from Vittoria's ambition to become the Princess of Bracciano. To realize her goal it was necessary to eliminate not one but two 'obstacles': Isabella, and Vittoria's husband Francesco Peretti.

Perhaps Isabella had some premonition of the danger looming over her, because she sent a letter to Caterina of France asking her hospitality. She was already preparing for her departure when on July 16 Orsini turned up in Tuscany unexpected, inviting his wife to meet him in their villa at Cerreto Guidi, outside of Empoli.

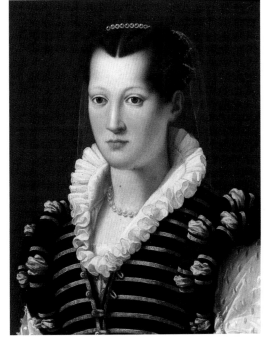

Facing page, bottom: Justus Utens, **Villa of Cafaggiolo**, detail from lunette painted on canvas (Florence, Palazzo Pitti, magazzino del Soffittone). In the foreground, in a symbolic photomontage, a portrait of Pietro by the school of Agnolo Bronzino (Florence, Uffizi). Located in the Mugello, the villa had been in possession of the Medici family since the days of Averardo. It was here that Cosimo I's son murdered his wife, Eleonora.

Below: **Isabella de' Medici**, by Agnolo Bronzino (Florence, Palazzo Pitti, Galleria Palatina). Like her sister-in-law, Isabella was doomed to a violent death at the hands of her husband Paolo Giordano Orsini.

Under the supervision of an elderly Giorgio Vasari, some of the best painters and sculptors in the city worked on the decoration of **Francesco's Study** in Palazzo Vecchio. The iconographic framework, dictated by the Grand Duke himself, encapsulates the naturalistic and alchemic knowledge of the day.

Notwithstanding her fears, Isabella responded to her husband's summons. That very evening, while bending over to kiss her, Orsini slipped a noose – previously concealed by the room's heavy curtains – around her neck. The cord passed through a hole in the ceiling drilled for the occasion, arriving in the room above where Orsini's henchmen hoisted her up by force. This death by strangling – or perhaps we should say, by hanging – was passed off as an apoplectic attack, but the burial registry in the Church of San Lorenzo did not overlook the fact that the young woman's face was disfigured by asphyxiation.

The murder of Peretti followed shortly thereafter, and the two lovers were free to marry. But they were not destined for an easy life: having married against the express will of Pope Gregory XIII, they were forced to live semi-clandestinely in Bracciano. In 1585 the Pope died and was succeeded by Sixtus V. For the homicidal couple, the situation turned dramatic, as the new pope was none other than Pe-

retti's uncle. Orsini had no choice but to seek refuge in Venice, where he died a short time later. In his will he left all of his earthly possessions to his new wife, inciting the rage of his relatives and particularly of his brother, Lodovico Orsini, who did not hesitate in having Vittoria murdered just six weeks after her husband's death. Lodovico himself was tried and condemned to death in Venice: from that moment on the Orsini family would never regain its antique prestige.

Francesco, scientist and man of letters

So far in our description of Francesco we have spoken primarily of his long love-affair with Bianca Cappello; but the fame won by this romance – characterized by an exclusiveness which foreshadows certain passionate attitudes typical of the Romantic Age – deserved a digression.

But what of Francesco the Grand Duke? His personality was quite different from the ambitious, tenacious and persevering one of Cosimo. On the other hand, he had inherited from his father not only the title of grand duke, but also a well-established, institutionalized power. This allowed him to leave a good part of the activities of governing in the hands of his ministers, dedicating himself to his favorite studies. More so than sovereign, in fact, Francesco was a scholar, particularly of chemistry and the natural sciences. The first to melt rock crystal for the making of vases, he also succeeded in his effort to produce a porcelain similar to that of the Chinese – in those days, the primary material, kaolin, was still unknown, as were the firing methods. He delighted in alchemy as well, and would pass entire days in his laboratory fusing metals, distilling liquors and developing pharmaceuticals. He also nurtured a passion for the stars and geography, and generously hosted astronomers and cartographers in his court.

This veritable infatuation with the sciences did not, however, make him lose sight of the arts, in keeping with one of the family's loftiest traditions. He is to be credited for the foundation of the "picture gallery" that, enriched over the

Left: Designed by Bernardo Buontalenti, this precious **vase** in lapislazuli, gold and glaze was realized in 1583 by French goldsmith Jacques Bilivert (Florence, Palazzo Pitti, Museo degli Argenti).
Below: Among the bronze figurines decorating Francesco's Study in Palazzo Vecchio one finds **Goddess Opi**, by Bartolomeo Ammannati.

Below, left: **The Glass Factory**, by Giovanni Maria Butteri (ca. 1540-1606), depicts a young Francesco visiting the kilns of Bortolo, the master glassworker that Cosimo had summoned from Murano in 1569.

Below, right: **The Alchemist's Laboratory**, by Giovanni Stradano, evokes the research and experimentation personally conducted by the Grand Duke (Florence, Palazzo Vecchio, Francesco's Study).

centuries, would come to constitute the museum of the Uffizi. In order to house the collection he ordered Buontalenti to enclose in glass the great *loggiato* of the Uffizi palace, which Cosimo had commissioned; the ground floor, on the other hand, was dedicated to civic offices, while the first floor housed artisan laboratories of various types, among which the famous tapestry school.

Although Francesco generally did not have much to do with the cares of government, he did oversee the implementation of his father's plans for Livorno, and called Buontalenti to develop the plan for a modern port city. Its strategic and commercial importance did not escape him, Livorno being the only maritime port that Tuscany could boast of: the port of Pisa was silting up, while Portoferraio, on the island of Elba, was small and inconvenient.

The dynastic question and Francesco's death

Ferdinando lacked legitimate heirs to the throne, nor could he realistically expect any, as Bianca Cappello was sterile. Upon his death the grand-ducal scepter would pass by right to Ferdinando, his cardinal

brother living in Rome. Relations between the two had never been good, and had grown all the more acrid after Francesco's second marriage. Ferdinando held his new sister-in-law unworthy of the throne and never missed an opportunity to slander her in public. This in spite of the fact that Bianca never bore him hard feelings; on the contrary, it seems that on several occasions she successfully acted as peacekeeper between the two.

One day, for the very purpose of sealing their umpteenth reconciliation, Ferdinando was invited to spend a few days with Francesco and Bianca in their favorite retreat, the villa in Poggio a Caiano. On October 8 1587 everyone took part in a hunting expedition from which the Grand Duke returned ailing and feverish. As always, he wanted to take care of himself with strange pharmaceuticals, either home-made or brought in from the Orient. Dilettantism in medicine can prove deadly, and Francesco's condition turned critical. On October 13 Bianca too was seized by a terrible fever that confined her to bed. They would both perish not long thereafter: Francesco on October 19 and Bianca eleven hours later.

The sudden, twin death couldn't help but arouse suspicions regarding Ferdinando, legitimate heir to the throne and bitter enemy of the Venetian. To put an end to the rumors, the new Grand Duke ordered an autopsy on the corpses. The tests concluded that Bianca had died of the dropsy that she had suffered for two years, while Francesco owed his end to the same strange medicines that he had abused. No traces of poison were to be found.

Anyway, Ferdinando continued to persecute his sister-in-law even after her death, refusing to grant her burial next to her husband in San Lorenzo. Today, Francesco reposes in the Medici Chapels at the side of Joanna of Hapsburg, while all traces of Bianca's tomb have been lost. And yet their love has remained as one of the greatest passions in the history of Florence, lasting twenty-four years without – as far as we know – either arguments or infidelity.

Left: **Processional helmet and visor**. For many years this elaborate coat of armor (along with morion and round shield) was thought to have been a gift to Duke Alessandro from Emperor Charles V; recent critics, however, sustain that the armor was in fact given to Francesco as a wedding gift. Below: Agate and gold cameo bearing **Francesco's emblem** (Florence, Palazzo Pitti, Museo degli Argenti). Above the image of the weasel holding a bough of rue in its mouth, there is a scroll that reads "Virtue against Fury." According to folk wisdom, the weasel is able to protect itself from the venomous toad by carrying a bough of the oderiferous plant. More common, but of analogous meaning, is Francesco's other motto, "amat victoria curam" (victory loves diligence); the expression is taken from a poem by Catullus.

The age of ambition

In 1587 Francesco was succeeded by Ferdinando I; in 1670 Ferdinando II drew his last breath. In little less than a century the dynasty consolidated, ascribing at times to a politics of "grandeur" accompanied by the obligatory marital alliances. Another Medici, Maria, ascended to the throne of France. Artistic patronage thrived, and Cosimo II, defender of the sciences, welcomed the great Galileo Galilei to Florence.

Ferdinando, the spendthrift cardinal

Ferdinando had remained in the papal court throughout Francesco's entire reign. He had preferred to keep his distance from Florence owing to the continual friction with his brother, especially aggravated after his marriage to Bianca. As was often the case among the nobility of this period, he had obtained the cardinal's hat for political reasons. His father Cosimo had arranged the nomination, falling back on him after the death of his brother Giovanni, who had been named cardinal while still a boy.

Ferdinando was not exactly the religious type, and in Rome he conducted the life of any aristocrat. Prodigal by nature, he spent considerably more than his means would allow, and had to resort on various occasions to Francesco's beneficence; even the detested Bianca interceded with her husband on his behalf. In Rome he had a residence built appropriate to his family's lofty status – the famous Villa Medici on the Pincio – and started a

Equestrian monument to **Ferdinando** in Piazza della Santissima Annunziata: started by Giambologna, it was completed by Pietro Tacca (1577-1640) in 1608. The base bears the Grand Duke's emblem, a swarm of bees accompanied by the motto "Maiestate Tantum."

Below, left: When Ferdinando de' Medici left Rome and his cardinalate to assume the title of grand duke, he brought Jacopo Zucchi (ca. 1542-1596) along with him. In this oil painting on copper Zucchi depicts the **Rest after the Flight to Egypt** (Florence, Depositi della Soprintendenza per i Beni artistici e storici). The work is listed in the 1588 inventory of Villa Medici, Rome.

Below, right: **Christine of Lorraine**, by Santi di Tito (1536-1603). The depiction adheres to the official canons of the day: the Grand Duchess's pose can be found in many court portraits of the period. The work is displayed in what was the seat of the Medici government in Siena, acquired by Ferdinando in 1593 and known today as Palazzo Reale.

collection of antique statues, his true passion. It is not by chance that the finest Greek sculptures in the Uffizi Gallery (the *Medici Venus*, brought from Hadrian's Villa in Tivoli, *Niobe and her children*, the *Dancing Faun*, the *Warrior*, the *Arrotino* and the *Apollino*) all arrived on his impetus.

By the way, the Florentines seem to have welcomed the arrival of the new grand duke with enthusiasm.

Ferdinando I's promising debut

Their optimism was well-founded. Contradicting years of luxurious idleness in Rome, Ferdinando quickly proved to be an able statesman, and his twenty-two years in power would be extremely positive for Florence and Tuscany. First of all, he cast off his religious garb (without any great remorse) because, as Grand Duke, he would have to marry to ensure the future of the dynasty. His choice fell upon Christine of Lorraine, daughter of the Duke of Lorraine and Claudia (daughter of Henry II and Caterina de' Medici). With this union Ferdinando hoped to reinforce the relationship between Tuscany and France, a relationship that Cosimo and Francesco's pro-imperial policies had somewhat compromised. Caterina gave her full consent to the marriage of her beloved granddaughter with Ferdinando, but the French court did everything possible to prevent the union, above all

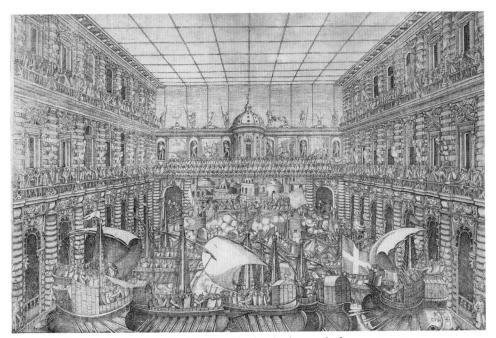

for the malicious rumors regarding Ferdinando that had spread after the death of his brother and sister-in-law. In other words, the Queen Mother was accused of wanting to marry her granddaughter off to an assassin, and first the death of the Duke of Lorraine and then the critical situation in France postponed the marriage. During Caterina's final illness her granddaughter never left her side, and it was only after her death that she would embark upon the journey to Florence. She was a plain woman, already twenty-four years old, which in those days was considered an advanced age to marry. For his part, Ferdinando (born in 1549) was nearing his forties. Notwithstanding the age difference, the union proved to be a truly happy one, and the period in which Ferdinando and Christine lived in Palazzo Pitti remains one of the last serene moments in the family's history.

Above: Orazio Scarabelli, **Naumachia** (Florence, Uffizi, Gabinetto Disegni e Stampe). For Ferdinando de' Medici's wedding to Christine of Lorraine (May 11 1589), Ammannati's courtyard was flooded to accommodate a simulated naval battle. The idea was classical in origin: the Coliseum in Rome was equipped with an hydraulic system specially designed for such battles. In those days the spectacle was a bloody affair, as the vessels that confronted one another were manned with armed gladiators.

Public works and "grandeur"

Ferdinando I seemed sincerely interested in the well-being of his subjects. His first public act consisted in the institution of a convalescent hospital in Piazza Santa Maria Novella, on the site of the former hospital of San Paolo. Until then, poor patients were discharged immediately after their recovery, but their precarious living conditions often resulted in relapse. The convalescent home of San Paolo

Right: Bernardo Buontalenti (1523-1608), **Delphic Couple**, pen and watercolor on paper. The sketch was drafted for the interludes of the "Pellegrina" (The Pilgrim), a musical drama by Ottavio Rinuccini and Giovanni Bardi di Vernio. Facing page, left: **Arion Citharaedus**. The character was interpreted by famous musician Jacopo Peri, known as Zazzerino, who specialized in a particular form of monodic singing fairly close to "recitar cantando" (lyric recitative). The opera was enacted in 1589, in the context of the celebrations for the wedding of Ferdinando and Christine of Lorraine (Florence, Biblioteca Nazionale Centrale). Responsible for the costumes and scenography was Bernardo Buontalenti, one of the primary exponents of Mannerist architecture in Tuscany. He was also involved in the shaping of the Boboli Gardens, taking over in 1569 where Ammannati had left off. An ambitious man, the artist convinced Francesco to demolish the medieval façade of the Florentine Duomo, hoping to implement his own design; a dream which was to remain unfulfilled, as the Grand Duke died before work was under way. As military architect, Buontalenti was involved in the building and strengthening of fortresses throughout the Medici dominion. Together with Leonora degli Albizzi and Cosimo I's natural son, Don Giovanni de' Medici, he designed the celebrated Fort Belvedere in 1590.

constituted an absolute novelty in Tuscany, and the Grand Duke's first gesture was welcomed by the citizenry as a good sign of things to come. His marriage to Christine seemed specially designed to make his subjects proud: the return of a high-ranking woman to the Medici household, and – what's more – the granddaughter of another Medici who had become Queen of France. The young bride was welcomed with great honors, and the city was completely decorated and transformed for the occasion. The celebrations that accompanied the Grand Duke's marriage lasted an entire month, during which the Palazzo Pitti courtyard was flooded in order to re-enact realistic naval battles, complete with miniature galleys. The spectacle would remain unequalled in the history of Florentine celebrations, exemplifying the climate of *grandeur* and pompous theatricality. Fittingly, the crest that Ferdinando I designs for himself is a swarm of worker bees surrounding the queen, bearing the motto *Maiestate tantum* ('Only with regal dignity').

Economic policy

From the outset of his rule the Grand Duke had to confront a difficult economic situation in Florence and in Tuscany overall. The Florentine primacy in textiles – traditionally based on a production of high quality purchased largely by the aristocracy – was by now but a fond memory. In fact the expansion of the market due to the rise of the middle class heightened the demand for inexpensive products. This market

was exploited by manufacturers on the other side of the Alps, particularly by the Dutch. Agriculture too remained unspecialized and technologically backwards in comparison with other regions.

Ferdinando managed to reinvigorate the economic situation, restoring at least up to a certain point the political and moral prestige of the court. He initiated large-scale reclamation projects: he had the boggy marshes of Val di Chiana (near Arezzo) drained, and initiated the consolidation of the plains of Pisa, Fucecchio and the marsh of Valdinievole. He furthered his father and brother's efforts to promote Livorno: as well as erecting jetties and fortifications, he established new fiscal regulations designed to draw a huge share of the international maritime traffic into the Tuscan port. To attract merchants and artisans to the city the so-called "Laws of Livorno" were put into place. These demonstrated a remarkably liberal perspective, declaring Livorno to be an open port, and guaranteeing asylum to all victims of political or religious persecution – from European Jews to French Huguenots, from the Flemish in revolt against the Spanish government of the Duke of Alba to the English Catholics. In a few years the city was populated. Hundreds of new artisans' shops opened, commerce thrived, and Livorno became second only to Genoa

Port of Livorno, crafted in semi-precious stone by Cristofano Gaffuri to a design by Jacopo Ligozzi (Florence, Uffizi). Founded by Cosimo I to compensate for the on-going silting up of Pisa, Livorno enjoyed under Ferdinando an unprecedented success that would last well into the following century. With the "Laws of Livorno," the Grand Duke granted free access to the port, and promoted religious freedom: as a result, the Jewish merchants, confined to ghettos and subject to vexations in other Italian states, flocked to the city. An habitual destination for English and French trading vessels, in the 18th century Livorno was a leading center of commerce and culture, as is testified by the printing there of a famous edition of Diderot and d'Alembert's "Encyclopédie."

Having already immortalized
Caterina's wedding (see
page 84), Jacopo Chimenti
known as Empoli, went on to
do the same for Maria's
(Florence, Uffizi). Celebrated in
1600, the wedding represented
the high point of Ferdinando's
matchmaking politics.

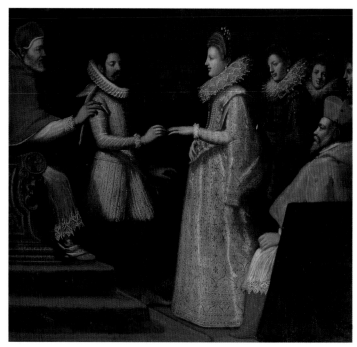

among Italian port cities. The so-called Naviglio – the canal the Grand
Duke had built to connect Livorno and Pisa – further heightened the
importance of the Tyrrhenian stop-over, and Tuscany found itself
holding a port of extraordinary commercial value. Under Ferdinando
I's rule, moreover, Tuscany enjoyed one of the best naval fleets on the
Mediterranean: in 1608 it even managed to defeat the Turkish one.

Foreign policy

These internal successes are matched by Ferdinando's skillful work in
the realm of foreign policy. After his promising debut in marrying
Christine, the Grand Duke succeeded in definitively mending rela-
tions with France. Following the assassination of Henry III (Cateri-
na's youngest son and last king of the Valois) the country witnessed
the umpteenth outbreak of war between Catholics and Protestants.
Henry of Navarre now headed the Huguenots, while the Guises were,
as usual, in command of the Catholic League. Ferdinando resolutely
took sides with Henry's forces, financing them generously for the
four years of war. A decisive help, if it is true that in these years the
annual income of the Tuscan Grand Duchy was equal to that of
France – if not greater. As a Protestant, Henry could not help oppos-

ing the Pope and the Church. Ferdinando urged him to convert to Catholicism, the only way to obtain the French crown and to end the civil war. The King of Navarre decided to convert, pronouncing – it seems – the celebrated line "Paris is well worth a mass." He assumed the throne in 1593 under the name of Henry IV. In compensation for his assistance, the Tuscan Grand Duke was assured that his niece Maria (born from the marriage between his brother Francesco and Joanna of Hapsburg) would be made Queen of France. Actually, Henry was already married to Caterina's daughter, Margaret of Valois, who, however, had still not born him an heir. In those days under these circumstancesthe woman was always held as the responsible party. The King was therefore amply justified in annulling his first marriage, going on to marry Maria.

From the moment of the official wedding announcement Florence enjoyed seven months of continual parties and dances in honor of the new Queen of France.

Ferdinando I and the arts

Among the many spectacles leading up to the wedding – celebrated by proxy in October 1600 – a performance of the drama *Eurydice* (with music by Jacopo Peri and text by Ottavio Rinuccini) took place in the Uffizi ballroom. The show made way for a veritable revolution, spearheaded by a group of artists from the Camerata de' Bardi, conducted by musician Vincenzo Galilei, father of the great astronomer. The Camerata de' Bardi, so called as its members convened in the palace of the Bardi di Vernio, was committed to innovating the musical form with the introduction of lyric recitative, thus laying the foundation for the birth of modern lyric opera. The reform was then crowned by Claudio Monteverdi who, in setting Rinuccini's *Ariadne* and *Orpheus* to music in the early 17th century, would initiate the success of the melodrama.

Ferdinando I followed the evolution of this phenomenon carefully, as he did with the development of all of the arts, new and old. It was he, in fact, who founded the famous Opificio delle Pietre Dure ('Workshop of Semi-Precious Stone'), still standing today, where marble and semi-precious stones were cut and inlaid to create designs of

Below, left: **Henry of Navarre** beside his first wife, **Margaret of Valois** (the famous Queen Margot), in a Flemish tapestry from the series **Celebrations of the Valois** (Florence, Uffizi). Below, right: **Elm panel with semi-precious stone** inlay, by Domenico di Battista del Tasso. Originally housed in Ferdinando's "Studiolo Grande," it is conserved today in the Mineralogy Museum (University of Florence, Geology Department). The Grand Duke instituted the "Opificio delle Pietre Dure" (Workshop of Semi-Precious Stone) for the decoration of the family mausoleum, whose cornerstone he laid on April 6 1604.

Design for the altar of the Chapel of the Princes, by Don Giovanni de' Medici and Matteo Nigetti (Florence, State Archive). This unimplemented design for the altar was surely done sometime after 1602, the year Ferdinando announced the competition.

unusual splendor. The Grand Duke saw to it that the Opificio's first task would be the decoration of the family mausoleum that, already envisioned by Cosimo and Francesco, was founded during this very period. On April 6 1604 Ferdinando personally laid the first stone of the great chapel situated at the flank of the Basilica of San Lorenzo. The design of the mausoleum – the celebrated Medici Chapels – is the work of Giovanni de' Medici – natural child of Cosimo I and Leonora degli Albizzi – with the collaboration of Bernardo Buontalenti and Matteo Nigetti. From the outset the project – an enormous octagonal chapel completely decorated with marble and semi-precious stones – appeared extremely ambitious, especially considering that the original design called for lapislazuli ornamentation to cover the entire interior of the dome. In the following century, however, the enormous cost of the enterprise would induce the recourse to frescoes.

Along with the Medici Chapels – finished only in the early 18th century on behalf of Anna Maria Luisa, the last exponent of the family line – Florence is indebted to Ferdinando for the completion of another imposing construction: the Fort Belvedere. Initiated by Cosimo I and furthered by Giovanni's design contributions, the fortress was inaugurated in 1595. Inside, Buontalenti constructed a treasure room, and only the Grand Duke and the architect were able to spring the ingenious mechanism giving access to the secret chamber.

Matrimonial policy

Christine of Lorraine bore Ferdinando no less than nine children: Cosimo, Eleonora, Caterina, Francesco, Carlo, Filippino, Lorenzo, Maria Maddalena and Claudia. For Cosimo, heir to the throne, Ferdinando set about finding a wife worthy of the prestigious grand duchy. His choice fell upon Maria Magdalena of Austria, daughter of Archduke Charles. An excellent candidate, as her sister Margaret was already married to Philip III of Spain, while her brother Ferdinand would be soon be elected emperor. The marriage was celebrated in the Basilica of San Lorenzo in June 1608. This was Ferdinando's last royal act, as he died a few months later, on February 7 1609. His remains were temporarily housed in the New Sacristy of San Lorenzo: he would be the first to be inhumed in the new family mausoleum. Ferdinando's reign would be sorely missed: it was, in a certain sense, the Medici family's swan song. In fact, the third grand duke had incarnated at least some of the qualities that had made his family great – political talent and a remarkable love for the arts. After him, the fall of the Medici would be unstoppable at the financial, political, and moral level. Their

dusk coincided with that of Florence, which would never again witness the golden years of Cosimo the Elder and Lorenzo the Magnificent.

Maria, Queen of France

At this point let us turn for a moment to Maria, whom, as we have seen, Ferdinando had succeeded in marrying off to Henry IV. The arrival of yet another Italian queen after Caterina was not likely to fill French hearts with joy, and in fact Maria, like her predecessor, would never be particularly loved by her subjects. When she arrived in France, she was "already" twenty-five years old, and could by no means be described as pretty. She did have, however, the attractive attribute of wealth, thanks to the very handsome dowry provided by her uncle, Ferdinando I.

The young woman embarked for Marseille with high hopes, but an unhappy life awaited her on the other side of the Alps. Caterina had had to struggle for years against Diane of Poitiers; Maria would have to contend with more than one of her husband's lovers – Henry was in fact renowned as great *tombeur de femmes*. By the time the marriage

Facing page, bottom: **Maria Magdalena of Austria** (Florence, Palazzo Pitti, Galleria Palatina), by Cristofano Allori (1577-1621). The chosen bride to Ferdinando's son and future Grand Duke Cosimo, Maria was daughter to Archduke Charles, and the sister of Marguerite, Queen of Spain, and Emperor Ferdinand of Austria. The wedding was celebrated in the basilica of San Lorenzo in 1608. Left: Tapestry bearing the **Medici coat-of-arms** united with the **emblem of the House of Austria** (Florence, Palazzo Pitti, Museo degli Argenti). Below: Pieter Paul Rubens (1577-1640), **Henry IV at the Battle of Ivry**. The painting depicts Henry's victory over Charles of Lorraine (1590), and is part of a cycle honoring the French sovereign. It was commissioned to the Flemish artist by Maria de' Medici.

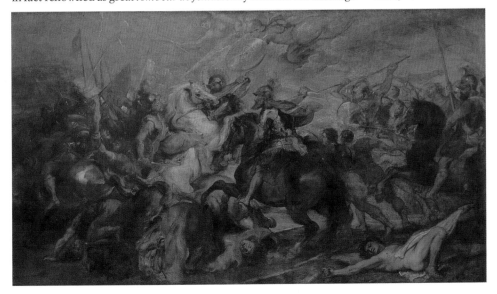

Below, left: Frans Pourbus the Younger (1569-1622), **Louis XIII at the age of ten.** Below, right: By the same artist, **Maria de' Medici, Queen of France.** Both portraits were done in 1611; Maria, who was thirty-eight at the time, looks particularly full-figured (Florence, Uffizi).

contract between Henry IV and Maria was made public, the King had already fallen into the arms of Henriette d'Entraigues, who even succeeded in obtaining a written promise of matrimony. But the King's real favorite was Gabrielle d'Estrées, and he had no qualm in presenting her to his wife upon her arrival from Italy. Maria, however, did not have Caterina's generally accommodating character: she was outraged by her husband's infidelity, and could not tolerate the thoughtlessness of a sovereign who casually allowed his illegitimate children to live in the court alongside those born of his marriage. But the Italian's pride – and not just pride: Maria really loved Henry, and her pain upon his death was great and sincere – did not meet with sympathy in the court circles, where it was held that the king had the right to live as he liked and the queen had to make do. The continual friction between the two did not, at any rate, impede the births of five children from their union: the future Louis XIII of France; Gaston, Duke of Orléans; Elisabeth, who would marry Philip IV of Spain; Henrietta Maria, future wife of Charles I of England; Christine, who would be married to the Duke of Savoy.

The dark years of the regency

When in 1610 Henry IV was felled by the dagger of religious fanatic Ravaillac, Maria assumed the regency by virtue of Louis' young age. Unlike Caterina, however, she did not prove up to the task, and surrounded herself with bad advisors. In leaving Florence she had brought along Leonora Doni Galigai, foster-sister as well as a friend from childhood and adolescence. Setting sail for Marseille, Leonora was escorted by a pleasant companion, also Florentine: Concino Concini. This adventurer soon became her husband, and the couple, generously financed by Maria, lived in luxury. The two were not long in becoming the Queen's inseparable confidants and advisors, but Maria was unable to recognize that the couple was acting in bad faith. The grumbling of the court, already on bad terms with Concini, reached new heights when Maria nominated him Marquis of Ancre. Leonora, on the other hand, assumed the completely informal role of superintendent of the Queen's wardrobe. All of the Queen's decisions during her seven years of reign were colored by the pernicious influence of the two; interrupted only when Louis XIII, turned sixteen, decided to liberate himself from the cumbersome tutelage of his mother and her omnipresent advisors. Concini was stabbed to death by a handful of hired assassins; Leonora was tried for witchcraft and burned alive. Maria was taken under arrest in the castle of Blois, where she would occupy the same apartment that Caterina had. After some time the Queen managed to escape, but Louis XIII, probably upon the advice of Cardinal Richelieu, decided to send her into exile. For Maria, forced to seek refuge in Holland, the situation was dramatic. Alone in a foreign land and deprived of her wealth, she turned to her daughter Henrietta Maria (wife to Charles I of England) for help. Receiving negligible assistance, she then moved on to Antwerp, where she met with anything but a warm welcome, and was even compelled to leave the city by order of the local authorities, who did not wish to make enemies with the King of France.

The last stop of her unhappy exile would be Cologne, where Dutch painter Pieter Paul Rubens also lived. Maria had welcomed him in her court, and had commissioned him for twenty-four large canvases to decorate the gallery of her Luxembourg palace. In these paint-

Left: **Maria**, in a bronze medallion attributed to Antonio Selvi (Florence, Palazzo Martelli). This portrait, although not entirely unrealistic, seems a bit idealized when compared to the one by Pourbus. The Latin inscription along the edge reads: "Maria ab Etruria Gal(liae) Regi(na)" (Maria, Tuscan by birth, Queen of France).

ings – with a grandiloquence in which it is possible today to detect a certain thread of more or less involuntary irony – Rubens illustrated the most important moments in Maria's French period, from her engagement by proxy with Henry to the most noteworthy episodes of the regency. Remembering the protection and princely treatment awarded to him years earlier, the wealthy Rubens offered the Queen a modest dwelling, where she would finish her days in 1642.

A not entirely negative legacy

Ambitious but naive, Maria had proven incapable of carrying out the role of queen. Like Francesco she lacked a calling for the art of government: twisted fate alone had conducted her to the throne that was the origin of her disgrace. Nevertheless, this second "Italian" had left a not entirely negative imprint during her passage in France. A true Medici, she had demonstrated a sincere love for the arts, and many painters, sculptors and architects enjoyed her patronage. Accustomed as she was to the magnificence of Palazzo Pitti, the Louvre – although partially renovated by Caterina – appeared too modest to her, and she set about refurbishing it. Even in her youth Maria was enchanted with the art of tapestry, and as queen she introduced it into her court, assembling a crew of artists to execute the designs then reproduced with the most precious of materials. Likewise, she filled the Louvre with furnishings and precious objects, transforming it into a lavish and refined royal palace. Her Florentine good taste guided her every choice: her masterpiece, the Parisian residence of Luxembourg, is a veritable "quotation" from Palazzo Pitti under transalpine skies.

Cosimo II, the mild grand duke

When he ascended to the grand-ducal throne Cosimo was just seventeen years old, and already afflicted with the tuberculosis that would carry him to the grave shortly after his thirtieth birthday. Like all of his brothers and sisters, he inherited a sweet and peaceful nature from his parents. Unlike many of their ancestors – especially their paternal aunts and uncles – Ferdinando I's children were never at the center of intrigues or criminal plots. On the other hand, almost all of them would have short lifespans. The second-born, Eleonora, died in 1617 at the age of twenty-eight: betrothed to Philip III of Spain, she was so distraught when the prestigious engagement was called off that some attribute her death to this disappointment.

Below: **Grain Loggia**, designed by Parigi at Cosimo II's request. The bust of the Grand Duke is located in the second nook in Via de' Neri (on the left side of the photo).

The third-born, Caterina, was widowed in 1626 by Ferdinando Gonzaga, Duke of Mantua; returning to Florence she was dubbed Governess of Siena, but just three years later died of smallpox. The fourth child, Francesco, died in 1614 at the age of twenty, while the fifth child, Carlo, would have better luck: ordained as cardinal, he lived to the age of seventy. Filippino, born in 1596, died just six years later. Maddalena, placed in the convent of La Crocetta, passed away at thirty-three. Claudia, the youngest, married Federico della Rovere – only son to the Duke of Urbino – in 1620. Widowed after just two years, she had to return to Florence with her young daughter Vittoria.

Amidst luxury and dreams of glory

But let us abandon this chain of bereavement – which, among other things, helps to explain the imminent extinction of the family name – in order to focus our attention on the new grand duke.

The marriage between Cosimo II and Maria Magdalena of Austria proved to be well matched and decidedly prolific, resulting in eight children: Maria Cristiana, Ferdinando, Giovan Carlo, Margherita, Mattias, Francesco, Anna and Leopoldo. The court life in Palazzo Pitti unfolded without any particular upsets, and Cosimo II decided to enlarge the building to accommodate his ever-growing family. The façade of the palace was therefore enlarged, and a terrace was adjoined to the back of the building on the level of the first floor. Thus the Florentine royal palace became all the more imposing, testimony that the need for *grandeur* so much alive in Ferdinando was perpetuated in his son.

Except, of course, this magnificence was by now practically prohibitive for the Medici: the great wealth of Cosimo the Elder's days had been exhausted for some time. And yet, notwithstanding the great ex-

penses sustained in the expansion of the palace and in the construction of the nearby villa of Poggio Imperiale, the Grand Duke resolved to close the Medici Bank, which at the time still had various branches throughout Europe. Apparently Cosimo II didn't plan to pay for the royal luxury that surrounded him out of his own pocket: he would rely instead on the taxes of his subjects. At any rate, his decision did not seriously weaken the grand-ducal finances that Ferdinando I had rendered truly prosperous; the consequences would become evident only in the years to come.

Cosimo's rule did not affect any particular change in foreign policy, also because the new grand duke's outbursts of bellicose enthusiasm were decidedly unprofitable. For example, a mirage of who knows what conquests in Asia Minor instilled him with the idea of a crusade against the Turks, but in all of Europe he was unable to find another sovereign daft enough to line up behind the project. He then befriended a sixteen-year-old Druze prince, Fakr ad Din, who boasted a sure ascendance over the middle Eastern peoples oppressed by the Turks and anxious to rebel. The promises of the prince turned out to be completely unreliable, and the good Cosimo abandoned his dreams of military glory once and for all.

Detail from **Galileo Galilei**, by Justus Sustermans (1597-1681). In this intense portrait done in 1636 the scientist looks not towards the spectator, but searchingly up towards the heavens (Florence, Uffizi). Facing, above: A **planetary mechanism** based on the Copernican system. The instrument displays the orbits of Mercury, Venus and the Earth around the Sun, as well as the movement of the Moon around Earth (Florence, Museo di Storia della Scienza).

The patron of Galileo

A realm in which Cosimo moved with greater skill was that of culture and science. Significant in this regard was the relationship that he developed with Galileo Galilei, father of modern physics.

Galileo was born in Pisa in 1564, son to the same Vincenzo that we saw at the head of musical reform with the Camerata de' Bardi. He was still quite young when he was appointed professor of Mathematics at the University of Pisa. His career's precipitous starts and his research findings that contradicted Aristotelian physics provoked the envy and spite of many of his colleagues. In 1592 the young scientist left Pisa to teach at the University of Padua, where Cosimo himself would be among his pupils. In Padua Galileo developed the telescope that would allow him to observe the surface of the moon, and to identify the four satellites of Jupiter. These he baptized with the Latin name of *Medicea Sidera* ("Medicean planets") in honor of the grand-ducal family. Cosimo, for his part, amply returned the favor: he invited Galileo to Florence. and created for him the title of "Head Mathematician of the Grand Duke," with a salary of a thousand scudi a year. Galileo was also given the villa of Arcetri, not far from Maria

Magdalena's new residence on Poggio Imperiale. It was here that Galileo discovered the phases of Venus.

The protection offered to Galileo was perhaps the most enlightened act of the reign of Cosimo II, who otherwise passed his brief life between luncheons, receptions and literary or scientific debates. Upon his death (February 23 1620) the will was opened, which he had prepared some time earlier in the knowledge that he was not destined for a long life. Therein he designated his mother Christine and his wife Maria Magdalena as co-rulers of the Grand Duchy, to be succeeded by his first-born Ferdinando, who was just eleven at the time, upon his coming of age. This unusual choice of assigning mother and wife to the throne would have, however, profoundly negative consequences for Florence and for Tuscany overall.

Left, below: **Ferdinando II** in a portrait by Justus Sustermans. Cosimo II's heir is depicted at the age of twenty (Florence, Palazzo Pitti, Museo degli Argenti).

Too many habits in court

Cosimo II's testament imposed a long series of restrictions on the two rulers, conceived to safeguard them from possible profiteers and above all to maintain the family patrimony intact in wait of Ferdinando's coming of age. Four ministers nominated by Cosimo were to remain at the side of the two women: all Florentine (a French mother and Austrian wife might summon foreign ministers), all lacking blood ties with the family (a Medici might have an interest in eliminating the legitimate heir in order to succeed him). As far as his private treasure was concerned, the Grand Duke established iron-clad rules: the two women were not to touch it except in case of a natural disaster – and thus on behalf of the population – or else to give it to the family's daughters as a dowry. In Cosimo II's will we find a good dose of wisdom and foresight – gifts he had not particularly demonstrated in life. Unfortunately both Christine of Lorraine and Maria Magdalena of Austria would not be up to the task. First of all the family lived in unprecedented luxury, which in the end

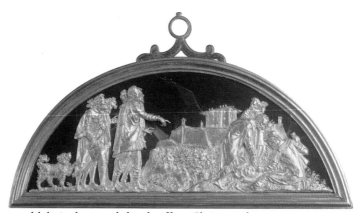

Right: Cesare Targone, **Fortification of Belvedere in Florence** (Florence, Palazzo Pitti, Museo degli Argenti), to a design by Giambologna. The bas-relief in gold and jasper includes Bernardo Buontalenti's design. During the plague epidemic of 1630-1633, the grand-ducal family sought refuge in the little palace on the hill.

Below: Giovanni da San Giovanni (Giovanni Mannozzi known as, 1592-1636), **Wedding Night** (Florence, Palazzo Pitti, Galleria Palatina). This painting was almost surely commissioned by Don Lorenzo de' Medici, Ferdinando II's uncle, on the occasion of his nephew's marriage to Vittoria della Rovere. The artist handled the theme, set against a working-class backdrop, with blatant irony: the bride in her nightgown (on the left) is pushed towards the wedding bed by three young women, presumably married friends. To the far left, an elderly woman – perhaps the bride's mother – looks on with ill-concealed trepidation. To the right, the husband lies bare-chested on the bed, impatiently extending his arms towards the bride. The scene unfolds under the watchful, yet uncomprehending gaze of the little dog. One can assume that the painting, rich in ribald allusions, was destined for the private enjoyment of the Grand Duke, victim of his mother's and grandmother's obsessive bigotry.

would drain the grand-ducal coffers. Christine, the true sovereign, was a religious fanatic and quickly succumbed to the influence of unscrupulous clergymen, whose advice the Grand Duchess passively accepted and rewarded with generous contributions. The eight years of co-rule were thus disastrous for the Tuscan court, headed for a decline as swift as it was irreversible.

As we have already noted, Claudia – Cosimo's sister and thus aunt to the future Ferdinando II – returned to Florence in 1623 following the death of her husband Federico della Rovere, Duke of Urbino. She brought along her daughter Vittoria (born 1622), sole heir to the duchy still ruled by Claudia's elderly father-in-law. Now, at the age of two Vittoria was married to the eleven-year-old Ferdinando so that he could inherit the status of ruler of Urbino. The plan, however, was contested by the new pope Urban VIII. The duchy had formerly been conceded to the Della Rovere by the Roman Curia, but now the Pontiff decided to reclaim it in order to grant it to his own family, the

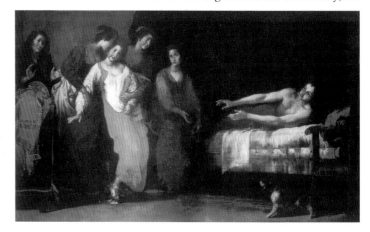

Barberini. Taking advantage of the fact that the elderly and decrepit Francesco Maria was in no condition to withstand a clash with the Church, Pope Urban promulgated a bull declaring that the succession of the duchy be granted to male heirs alone. According to this document Vittoria could expect only the family's movables. Nevertheless, the Medici advanced another claim on Urbino. Queen Caterina of France was in fact the daughter of Lorenzo, Duke of Urbino, and before dying had passed all rights to the Medici estate (including the duchy) on to her granddaughter Christine of Lorraine. Hence, Ferdinando II could claim direct rights to Urbino not only by means of his wife. Nevertheless, in wait of Francesco Maria's death, the Pope sent his troops into the duchy. No one in Florence opposed the move, and a short time thereafter the Medici formally accepted the annexation of Urbino into the Papal State, claiming only – and without much conviction – some of its movables.

Justus Sustermans,
Vittoria della Rovere in her Wedding Gown
(Florence, Palazzo Martelli).

Ferdinando II comes of age. The plague of 1630-1633

In 1628 Ferdinando II assumed the grand-ducal throne. The beginning of his reign coincided with a grave calamity that befell all of Tuscany: the plague of 1630, drawing out for many months and then returning to strike anew in 1633. The young grand duke proved to be an enlightened prince, and confronted the "Black Death" with rationality and a humanitarian spirit. Having sequestered his family in Fort Belvedere – that thanks to its elevated location preserved the members of the court from the city's miasma – he established sanitariums and an Office of Hygiene in order to isolate and cure the victims of the disease. Expenses and precautions were, however, of limited value: in the city and outlying areas there were twelve thousand victims.

The plague was also the indirect source of conflict with the papal court. Urban VIII resented the transformation of convents and monasteries into sanitariums, considering it to be an intolerable encroachment of temporal power into ecclesiastic jurisdiction. He censured the Florentine Office of Hygiene; and the Grand Duke, although animated by the best intentions, gave in to the Pope's will and agreed to close it. Ferdinando's acquiescent attitude was related to his youth as it was to his weakness of character, and perhaps even more so to his deference in the face of his grandmother Christine of Lorraine, yielding as always to ecclesiastical influences.

The trial of Galileo

Galileo too was an indirect victim of the plague. As the city was under quarantine, the scientist published his *Dialogue Concerning the Two Chief World Systems, Ptolemaic and Copernican* (1632) without first submitting a draft to the Holy Office, responsible for checking the correspondence of a work with the tenets of faith. His failure to send the *Dialogue* to Rome was interpreted by the Pope as an attempt to bypass ecclesiastical censure. Besides, the Jesuits had kept their eye on Galileo for years. In 1611 the late Pope Paul V had generously received him in the Vatican; five years later, the scientist was compelled to retract his adhesion to the Copernican theories. Nevertheless, until 1624 the scientist had been allowed to continue his studies undisturbed thanks to the Grand Duke's protection. Urban VIII, however, was already embittered over the Urbino question, and the publication of the *Dialogue* pushed him over the edge. As had been the case with the sanitariums, Ferdinando II bowed at once to papal authority and did not utter a word in Galileo's defense. In 1633 the scientist was compelled to return to Rome to submit his work to the tribunal of the Inquisition: it would be judged as heretical as it strayed from the precepts of the Scriptures. Galileo, who at the time was seventy and in poor health, was forced to abjure, that is, to retract his theories, upon the pain of imprisonment or even worse. He was allowed to return to Florence, where he spent his remaining time between the villa of Arcetri and his residence on Costa San Giorgio. Upon his death in 1642 Ferdinando resolved to erect a monumental tomb for him in Santa Croce, where he was buried; but the Jesuits firmly opposed the project and the Grand Duke once again bowed to the clergy's will. Only in 1737, on the brink of extinction, would the Medici make amends for the wrongdoing with the monument still standing in the left-hand nave of the Basilica.

Hard times for the Grand Duchy

In 1634 Ferdinando II and Vittoria della Rovere inaugurated a conjugal life that, unlike that of his father and grandfather, would prove to be a most unhappy one. Contributing to its tormented nature would be on the one hand, the Grand Duke's homosexual tendencies, manifest from an early age; on the other, the exasperating fanaticism of Vittoria, who had been raised in a convent and would be dominated by religious authority all of her life. From this unfortunate match were born four children: the first two survived just a few hours; Cosimo was born in 1642, and Francesco Maria in 1660. Christine of Lorraine had died in 1636 leaving an ugly inheritance: the state apparatus was teem-

Over the centuries the former home of the Medici on Via Larga has undergone significant modifications. During the 17th century Pier Maria Baldi designed the gallery on the first floor: here great cabinets were installed to store the family collection of jewels, medallions and rare or curious objects. The gallery ceiling was frescoed between 1682 and 1683 by Luca Giordano (1632-1705) with **Allegories of the Medici**, in which the artist made full use of his inventive genius.
Facing page: A detail from the great composition. Below, one finds Glory, crowned in laurel, embraced by Liberty, who, in turn, is solicited by the man in chains to the right. Above, the Medici insignia in the form of a shell hovers in the sky, accompanied by putti.

In 1652 Francesco De Cecchi and Marco Credo dedicated this print of the fountain of the Boboli's **Isolotto** (more precisely, the Ocean Fountain), to Ferdinando II. Work on the gardens began in 1550 at Eleonora de Toledo's request. Tribolo was succeeded by Buontalenti and other architects, including Parigi. The latter was responsible for the majestic descending avenue known as the "Viottolone," lined with statues like **Aesculapius and Hippolytus** (below), by Giovanni Battista Caccini (1556-1613). The marble group alludes to the medicinal value of plants.

ing with clergymen, who had infiltrated all levels of public office, while the monastic orders – traditionally exempt from taxes – boasted proprietorship of enormous tracts of land. The financial pressure thus fell squarely on the middle classes, discouraging manufacturing and commercial investments and provoking incalculable damage to the economy. What had once been the most thriving state in Europe now capitulated to the interference of religious orders; nor would Ferdinando prove capable of resolving the situation. In striking contrast to the wide-spread poverty, the luxury enjoyed by the grand-ducal family continued unchecked: in 1640 the Grand Duke decided to enlarge the royal palace, and the dimensions of Palazzo Pitti nearly doubled. In the meantime, the Opificio delle Pietre Dure continued its work on the family mausoleum: Ferdinando, a great admirer of the new art form, had no hesitation in investing enormous sums.

Relations with the Church and family politics

Urban VIII died in 1644, and with Innocent X's ascension to the papal throne many things changed for the better in the relationship between Tuscany and the Vatican. The new pope promptly demonstrated a marked favoritism for the Grand Duchy, which, in turn, showed no signs of straying from the politics of deference begun during the regency. In order to reinforce the relations compromised by his predecessor, Innocent X conferred the cardinalate to Ferdinando's brother, Giovan Carlo, who had already assumed the direction of state finances upon the Grand Duke's request. The other brother, Mattias, was nominated army commander and governor of Siena, while Leopoldo, the youngest, was a sort of unofficial minister of culture. The Grand Duke's decision to involve all of his brothers in the government can be interpreted in two opposite ways. Perhaps it re-

flected a desire to confer all power to his family, regardless of the actual capabilities of its members; or perhaps it was a gesture of responsibility, the sign of an identification between the destiny of the family with that of the Grand Duchy. In any case his policy was unable to halt the progressive political and economic decline of the state.

The Accademia del Cimento. Science and erudition

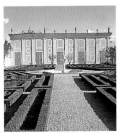

Among Ferdinando's brothers Leopoldo emerged undoubtedly as the most gifted, demonstrating a particular love for the arts and sciences. It was he who founded the celebrated Accademia del Cimento (1657) adopting as its motto the fundamental principle of experimental science: "Provando e riprovando" ('By trying and trying again'). The first European society dedicated to the natural sciences, the Academy served as a model for analogous institutions in England (the Royal Society) and France (the Académie des Sciences of the Institut de France). It also served as a magnet for several of Galileo's students, among which Evangelista Torricelli (who formulated the first theory of atmospheric pressure and invented the barometer), Giovanni Borelli and Vincenzo Viviani (who in 1656 measured the speed of sound). Thanks to their work Florence would once again attain, albeit briefly, a leading role in the realm of scientific research. Leopoldo corresponded with all of the major European scientists, and some of them decided to settle in Florence, as did Danish doctor and geologist Niels Stensen. After 1667 – when Leopoldo, made cardinal, moved to Rome – the Academy wound up closing its doors. An interesting testimony to that dynamic decade can be found in Lorenzo Magalotti's *Essays on natural experiences*. Leopoldo entrusted the reorganization of the court library (still housed in Palazzo Pitti and therefore known as 'Palatine') to the great bibliophile Antonio Magliabechi. Regarding this extraordinarily famous scholar – King Louis XIV of France and Emperor Leopold of Austria consulted him on various occasions – there runs the following anecdote: among the pages of many of his books were to be found the remnants of salami slices which, reading while he ate, he used as bookmarks! The Palatine Library would come to include 14,000 manuscripts and some 200,000 printed volumes. This rich patrimony, along with Magliabechi's private collection, would go on to form the first nucleus of the Biblioteca Nazionale Centrale in Florence.

The **"Casino del Cavaliere"** (Knight's Lodge) gracing the Boboli Gardens. Built for Cardinal Leopoldo and expanded by Cosimo III, it later served as study to Gian Gastone, the last representative of the dynasty. It has hosted the Porcelain Museum since 1973.
Below: Giovanni Battista Gaulli known as Baciccio (1639-1709), **Cardinal Leopoldo** (Uffizi, Vasari corridor).

Art collecting

It is to the joint initiative of Leopoldo, Ferdinando and Giovan Carlo that we owe the birth of the art collections that were to constitute the Uffizi and Palatine

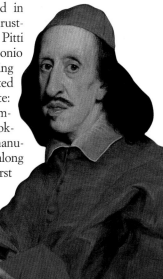

Ferdinando II's brother Don Mattias de' Medici was present at the siege on the Coburg Castle during the Thirty Years' War. Upon its conclusion he brought back a series of thirty **ivory towers** sculpted by Marcus Heiden and Johann Eisenberg, formerly belonging to the Duke of Saxony and the Prince of Coburg. The precious objects (above, three exemplars) are now conserved in Palazzo Pitti's Museo degli Argenti. Below: Commissioned by Guidubaldo II della Rovere in 1538, the so-called **Venus of Urbino**, by Titian (ca. 1488-1576), reached Florence in 1631. The inestimable painting was part of Vittoria della Rovere's inheritance.

Galleries. Francesco and Ferdinando I had already pulled together part of the family collection in the Uffizi. Their successors assembled the works in their entirety, including their own private collections, and that of Vittoria della Rovere. Upon marrying Ferdinando II's wife had brought to Florence as dowry many pieces of furniture and ornaments from the ducal palace of Urbino: thus were added to the Medicean collection such works as the celebrated portraits of Federico, Duke of Montefeltro and his consort Battista Sforza, by Piero della Francesca, as well as the *Venus of Urbino* and the *Magdalen* by Titian. To accommodate this great patrimony it was necessary to enlarge the Uffizi Gallery, that almost tripled in size. Along with the paintings, room was found to house Ferdinando II's collection of gems and rare vases.

Cosimo the heir: upbringing and marriage

Although the Grand Duke demonstrated – especially on the cultural front – a minimum of autonomy from the suffocating ecclesiastical tutelage, his wife was no less reactionary than the two women who had preceded her in Palazzo Pitti. Since Ferdinando neglected his heir, Cosimo was entrusted to her exclusive care, and her religious fervor thus colored his entire upbringing. The boy displayed a considerably different character from that of his predecessors. He was gloomy and taciturn, and lacked any interest whatsoever in the arts or sciences. When he reached marrying age, his father, for once, took the matter into his own hands, personally choosing his son's future consort. He opted for Marguerite-Louise of Orléans, orphan of Duke Gaston (son of Maria de' Medici, Queen of France) and cousin to Louis XIV. Marguerite-Louise was raised in the vain hope – fostered by her mother Marguerite of Lorraine – that she would one day marry the Sun King. What's more, in the meantime she had fallen in love with her cousin Charles of Lorraine. But before dying her father Gaston had placed the girl's fate in the hands of Louis, who favored the Italian match, leaving no room for discussion. In 1661 a less-than-enthusiastic Marguerite-Louise married Cosimo by proxy in the Louvre, and then, accompanied by Mattias, embarked for Livorno. Notwithstanding the great honors that were awarded her from the outset, Marguerite-Louise never liked Florence nor Tuscany, to the point that she would die without ever having learned Italian. The union with Cosimo turned out to be a complete disaster, largely owing to the irreconcilable conflict between his sullen unhappiness and her lively spirit. The fights were continual and considerably more serious than those between Ferdinando II and Vittoria della Rovere. In 1663 the couple brought their first child to light – named Ferdinando in honor of his grandfather – but the arrival of an heir did not change the family scenario and the quarrels continued unabated. On several occasions Louis XIV tried to placate Marguerite-Louise sending ambassadors to Florence who alternated supplications with threats, but all efforts proved in vain. In 1667 the couple's second child – Anna Maria Luisa – was born, followed in 1671 by Gian Gastone, who would be the last grand duke of the House. Ferdinando II did not live to see his last grandson. Dying at the age of sixty in May 1670, he left the Grand Duchy – already in a very precarious state – in the hands of an incompetent son.

Marguerite-Louise of Orléans, Cosimo III's wife, in an anonymous portrait (Florence, Museo Bardini).

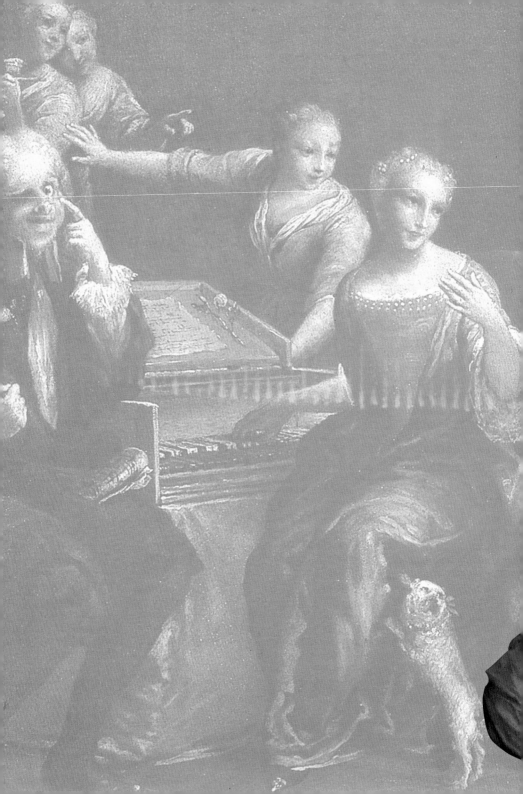

The twilight of the dynasty

Twilight fell upon the Medici dynasty, as it were, under the sign of the woman. For better and for worse: the weak Cosimo III cowered under the bigotry of his mother Vittoria, and his wife Marguerite-Louise; but upon the death of Gian Gastone – the last, impotent Medici grand duke – his sister Anna Maria Luisa would leave to Florence an invaluable patrimony.

Cosimo III, a moralist in Palazzo Pitti

One of the first consequences of Ferdinando II's death was the outbreak of a domestic conflict between Vittoria della Rovere and her daughter-in-law Marguerite-Louise of Orléans. As long as the old grand duke was alive, the conjugal quarrels between Cosimo and Marguerite-Louise – bitter and chronic though they were – remained within tolerable limits. With his demise the fragile equilibrium was shattered. Vittoria was largely to blame in precipitating events: freshly-widowed, she aspired to an active role in the affairs of the State. The influence she wielded over her son provoked Marguerite-Louise, who in turn asked Cosimo III for a role in government. Gone were the days when the Medici women lived quietly in the shadows, guaranteeing their husbands a serene familial backdrop, a refuge from the storms of public life. The new grand duke denied his wife's request. As a consequence, she asked for a separation and the permission to return to France: the marriage had fallen completely to pieces. Probably upon his mother's advice, Cosimo agreed to the separation: in 1674 Marguerite-Louise returned to Paris, taking up lodging in the Benedictine monastery of Montmartre. This event would have a negative impact on the Tuscan Grand Duchy, not for the loss of Marguerite-Louise, but rather for the decisive role as-

Carlo Andrea Marcellini (1646-1713), **Cosimo III de' Medici**. The bust of the Grand Duke decorates, along with those of his three predecessors, the façade of the 17th-century Palazzo delle Missioni in Piazza Frescobaldi.

Fair in Poggio a Caiano, by Giuseppe Maria Crespi (1665-1747). It was painted in 1709 during the artist's stay at the Medici villa. His host Ferdinando held the painter in special regard. Below: **Pietà** (detail), by Michelangelo. Sculpted between 1548 and 1555, this was his third group on the subject, following the one in St. Peter's in Rome, and the so-called "Rondanini Pietà." It was brought to Florence by Grand Duke Cosimo III. The artist intended the statue to serve as his own funeral monument; instead, the masterpiece was placed in the crypt of San Lorenzo, and then in the Duomo. It is now on display in the Museo dell'Opera del Duomo.

sumed from that point on by Vittoria, among those most responsible for the downfall of the Medici house. Both of his brothers having passed away (Mattias in 1667 and Leopoldo in 1675), no one with good sense remained capable of positively influencing Cosimo. What's more, Vittoria convinced her son to dismiss some of Ferdinando's old ministers in favor of others with ecclesiastical background. In a few years the Grand Duchy became an object of derision for Italian and European sovereigns alike. The citizens were subjected to various moral regulations, some of which decidedly ridiculous. The "Ordinance on Low Windows", for example, declared that: "Since permitting young men to enter one's house to court the young girls, and allowing them to banter in the doorway or at the window, are enormous incentives to abduction, abortion and infanticide, it is hereby prohibited to allow young men inside, or to allow them to court, with or without permission, in the doorway or at the low windows." Popular festivals were censured while religious ones grew in number and importance: all things considered, a climate hearkening back to the times of Savonarola. Moreover, Cosimo III imposed higher taxes to maintain the extravagant excesses of the court. He then appointed himself as Minister of Justice, inflicting exemplary punishments that, in his judgment, would instill in his people the fear of God.

Ferdinando, the rebellious heir

Cosimo's children were raised in this suffocating, priggish atmosphere. The first-born Ferdinando, however, rebelled against his father and even more so against his grandmother. From adoles-

cence on, Ferdinando appeared disgusted by the religious fanaticism of his parents, and by the climate of hypocritical conformism that ruled in the palace: he, on the other hand, was drawn to creativity and to beauty. The youngster tried to distance himself from the court, and took to frequenting the villa of Pratolino so beloved to Francesco and Bianca Cappello. Here Ferdinando delighted in the splendid baroque garden with its looming statue of the giant *Appennino*, by Giambologna; he then asked architect Antonio Ferri to design an indoor theater for the villa dedicated to the music and art that he loved so much, and for which he had a certain competence, being a fair musician himself. The theater of Pratolino grew famous in Italy and Europe for the hospitality conceded to countless distinguished artists, at least for as long as its patron saint was able to protect it.

Having tolerated his son's anticonformism for some time, Cosimo III finally reacted, maintaining that Ferdinando had created in Pratolino – behind the screen of the arts – a dissolute environment, a sort of haven of free love. In fact, it was common knowledge that Ferdinando passed from female to male companionship with nonchalance, and showed no inclination to marry. The Grand Duke proceeded to have his son spied upon, placing him under the surveillance of priests and monks. In 1687 Ferdinando, anxious to escape paternal censure, requested and finally obtained his father's reluctant permission to leave Florence. But the story doesn't end here. Cosimo III resolved to find a wife for his rebellious son and succeeded in forcing a fiancée upon him: Violante of Bavaria, daughter of the elector Palatine Ferdinand and Adelaide of Savoy. After great resistance on the part of Ferdinando the wedding was celebrated in the Duomo in January 1689. The story goes that Violante promptly fell in love with her husband; Ferdinando, for his part, had no interest whatsoever in this simple, ingenuous German, not to mention married life in general. He soon returned to his old habits, regularly leaving Florence in search of "romantic" adventures, and naturally legitimate children were out of the question. Though suffering terribly, Violante tolerated the vagabond ways of her husband, and was always ready to forgive him. Drawn to Venice and its famous Carnival, Ferdinando attended once more in 1696, but this would be a fatal visit: upon his re-

Justus Utens, **Villa of Pratolino**, lunette painted on canvas (Florence, Museo di Firenze com'era). Buontalenti gave free rein to his imagination in the design of the park's water games and moving figures. The villa was razed in 1822, and the park conserves only a shadow of the splendid decorative layout described by Montaigne in 1580.

The Villa of Pratolino was bought and reconstructed by the Demidoff princes in the early 19th century. In the park one can still admire the enormous statue known as the **Appennino**, by Giambologna. Francesco intended the statue to serve as a celebration of the family's Mugellan origins. The figure bears the following Latin motto: "ex Appennino, celsaque ex aere Mugelli nobilitas Medicum Thuscanam descendit in urbem" (From the Apennines and rarefied air of the Mugello, the noble Medici descended into the Tuscan city).

turn to Florence it was discovered that he had contracted syphilis. The course of the disease, slow but inexorable, conducted him to the grave in 1713. As Ferdinando died childless, it would be Gian Gastone to inherit the throne.

Marriages in the family. Gian Gastone's youth

Meanwhile, the health-conscious and temperate Cosimo III followed to the letter the prescriptions of his trusted "doctor-poet" Francesco Redi (author of the celebrated dithyramb *Bacchus in Tuscany*), and continued to enjoy excellent health. He would reign until 1723 reaching the venerable age of eighty-one, a true record for the generally short-lived Medici clan. During his reign the coffers of the State had been progressively weakened by the incredible largesse benefiting this or that religious order, to say nothing of the scores of priests who lived off of the grand-ducal family and were handsomely rewarded for occasional delatory services.

In the meantime Anna Maria Luisa – the second of Cosimo's children – had celebrated a "German wedding" of her own: the groom was none other than the elector Palatine Johann Wilhelm of Düsseldorf. This proved to be a successful match, but also, unfortunately, the indirect cause of other troubles for Cosimo's youngest son. At this point, Gian Gastone had reached marrying age. Introverted and inclined to solitude, he was raised essentially motherless, by a father that never thought much of him. Indifferent to public affairs, he loved the arts and sciences – especially botany. His older sister, who loved him fondly, felt obligated to arrange a marriage for him, a well-intentioned gesture that would have disastrous results for Gian Gastone. Anna

Maria Luisa, in fact, set her eye on Anna Maria Franziska, daughter of the Duke of Saxe-Lauenburg. The young woman was widowed by the Palatine Count Philip of Neuberg who – it seems – took to drinking in order to forget about his plain, simple wife, who was and would always remain completely absorbed in hunting and other outdoor activities. Anna Maria Franziska doggedly opposed the marriage, probably realizing that she was not cut out for conjugal life, but in the end she was compelled to surrender to the collective will of Cosimo III, elector Palatine Johann Wilhelm and his wife. The wedding was celebrated in Düsseldorf in 1697, and it was decided that Gian Gastone would live in his wife's homeland. Here, as could well be predicted, the difficulties emerged almost at once. Anna, who lacked any inclination whatsoever for the arts or sciences, lived in a small and dismal castle near Reichstadt, a tiny village perched in the mountains of Bohemia. Exiled at the side of a wife who by far preferred the pleasures of hunting to those of the nuptial bed, surrounded by an hostile countryside, Gian Gastone became more melancholy than ever, and after a year fled to his mother in Paris. Compelled by Cosimo III to return

Jan Frans Van Douven (1656-1727), **Johann Wilhelm of Düsseldorf with his wife, Anna Maria Luisa de' Medici** (Florence, Uffizi). Wilhelm holds the royal scepter in his right hand, and with his left supports a pillow bearing the imperial crown. This detail renders the painting easily datable: it was in 1711 that Wilhelm played the role of imperial vicar. The electress Palatine holds an olive branch, symbol of peace, in her right hand; the little dog at her feet symbolizes loyalty.

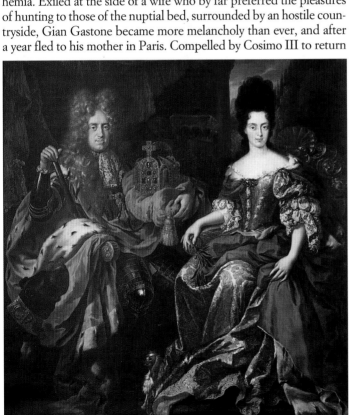

Niccolò Cassana (1659-1713),
Gian Gastone de' Medici
(Florence, Uffizi).

to Bohemia, he then took to frequenting Prague to get away from Anna Maria Franziska. Here he would pass his time not, as one might imagine, in the libraries or laboratories, but in the pubs. In short, Gian Gastone wound up an alcoholic. Meanwhile in Florence Prince Ferdinando was dying. The elderly Cosimo III called his youngest son, future grand duke, back to the homeland, and for ten years (1698-1708) tried in vain to bring back his wife as well. After the couple's definitive separation Cosimo III had to grapple in advance with another serious problem: the succession to Gian Gastone who, like Ferdinando, remained childless. Indefatigable, Cosimo compelled his fifty-one-year-old brother Francesco Maria to abandon the cardinal's hat and marry Eleonora Gonzaga di Guastalla. Alas, Francesco Maria died heirless in 1711, a year after the wedding; but then again, had the union lasted longer, the result probably would have been the same, given Francesco Maria's notorious homosexuality.

The hereditary issue

The source of on-going anxiety for Cosimo III, the hereditary issue was also of considerable interest to many European sovereigns, ready to intervene in the event of Gian Gastone's death for rights to the throne. In 1714, however, during the course of negotiations at Utrecht, Cosimo III succeeded in guaranteeing the right to succession to his daughter Anna Maria Luisa, electress Palatine. Two years later the widowed Anna Maria Luisa returned to Florence, where she found her father debilitated by old age and her brother drowning in alcohol. In 1718 England, Holland, France and Austria signed a secret treaty in London, establishing that upon Gian Gastone's death the rights to Tuscany would pass to Charles of Bourbon, oldest son of Elisabetta of Parma (descendent of Cosimo II's daughter Margherita). When Cosimo III caught word of the agreement, he was outraged: determined to defend the Grand Duchy against foreign claims, he took the army and State's defenses back into his own hands, reinforcing the fleet, restoring the fortresses and instigating a massive conscription. At the same time, he saw to it that the Florentine Senate recognized the electress Palatine as legitimate heir, publishing a formal declaration

that no one could succeed the Medici without the Senate's approval. Consequently Anna Maria Luisa began to involve herself in the affairs of the State, without any sign of envy or jealousy on the part of Gian Gastone, alien as he was from the lust for power. Nevertheless it was he who ascended to the grand-ducal throne upon his father's death on October 31 1723.

The tormented personality of the last grand duke

Gian Gastone was fifty-two when he took his father's place, his culture, intelligence and charm having long since vanished in the Bohemian snows. He had grown old before his time, his sharp intellect and curiosity replaced by a melancholy veiled in sarcasm. He passed days on end shrouded in smoke and alcohol, and bordered on a truly precarious state of health: grossly obese, he was afflicted by an illness – possibly diabetes – that reduced him to a state of near-blindness. He no longer tried to hide his homosexual tastes, and his court was populated with a harem of well-paid street boys. The responsibility for such a sorry end does not fall upon his fragile shoulders alone. His father too deserves a share: Cosimo III had educated his children in a bigoted and oppressive environment, never searching to exploit their talents. Ferdinando and Gian Gastone were probably not born with the stuff of statesmen, but left free to live in their own fashion they would probably have enjoyed at least a peaceful and perhaps even productive existence. Initially Gian Gastone tried to turn things around, shaking himself from his torpor: he moderated his drinking, and seemed determined to supervise internal and external affairs; he also surrounded himself with enlightened ministers such as Filippo Buonarroti and Giulio Rucellai. He freed Palazzo Pitti from the band of clergymen who had taken root there since the days of Ferdinando II, suspending all subsidies that had been granted to them by his father and thus reviving, at least in part, the State finances. He involved Violante of Bavaria – the sister-in-law he had always liked and admired – in the management of the court, preferring instead to marginalize his sister Anna Maria Luisa, whom he had perhaps not forgiven for promoting his unhappy marriage. During the first years of his regi-

Giuseppe Maria Crespi known as "lo Spagnolo," the **Courted Songstress**. This clearly satirical piece portrays a nobleman in the act of bestowing jewels on a lovely popular singer. Gian Gastone's royal court was populated with dubious characters, and the Grand Duke himself hardly bothered to conceal his vices. His physical, moral and intellectual degradation was such that he spent most of his time in bed, neglecting even the most elementary standards of personal hygiene.

Justus Utens, **Villa of Lappeggi** (in the title, "La Peggio"), detail of lunette painted on canvas (Florence, Museo di Firenze com'era). Constructed by Bernardo Buontalenti for Grand Duke Francesco, the villa was transformed by Francesco Maria into a theater for grandiose parties. **Violante of Bavaria** – below, on a medallion coined in 1689 by Antonio Montauti – moved into the villa after the cardinal's death (Florence, Bargello).

me, the justice system improved as well, and although the death penalty was not officially abolished, no prisoners were condemned to death. Daily life resumed its antique rhythms, and the exhausting religious ceremonies were replaced by the games and entertainment that for centuries had animated the streets and squares of Florence. Violante had a high-profile role in this process, advising the Grand Duke with intelligence and good sense. Albeit briefly, the Florentine court regained something of its old splendor, while scholars and artists substituted the gloomy monks that had circulated in those halls since the days of Cosimo III.

Who will succeed the last Medici?

Outside of Tuscany, the great European powers continued to quarrel over succession. Gian Gastone succeeded only in assuring that the family estate – including Palazzo Pitti and various Medicean villas outside of Florence – be left to Anna Maria Luisa. In 1728 a mild illness suffered by the Grand Duke gave rise to hopes that his death was imminent, and the Emperor released an edict demanding that the citizens of Tuscany submit to Austrian will as far as succession was concerned. Gian Gastone was playing for time, and for a while seemed willing to accept Charles of Bourbon as heir to the throne, provided that his sister reserved the right to a role in the Cabinet as grand duchess.

In 1731 the situation was precipitated by Violante's death. For Gian Gastone the loss was irreparable: it was only thanks to her influence that he had not given in to his vices. In fact, after her death, he resumed his heavy drinking and surrounded himself with his old companions, headed by his faithful accomplice-servant Giuliano Dami. He almost never pulled himself out of bed, and many witnesses described him as a man who had lost all sense of personal dignity. Even his hygienic conditions were deplorable.

As Gian Gastone advanced inexorably towards a perhaps not unwelcome end, the European powers reached an accord for the succession in 1735: the Grand Duchy would pass into the hands of Maria Theresa, daughter of the Austrian Emperor and betrothed to Francis, Duke of Lorraine, who would renounce this title in order to adopt that of grand duke. When the news reached Florence, they provoked great concern: granted, the house of the Magnificent had never before sunk so low, but to end up in foreign hands was arguably worse. Gian Gastone denounced the decision, but remained unheeded. A few months before taking his last breath, he made a final decision doubtless worthy of his better days: he had a funeral monument erected to Galileo in Santa Croce.

On July 9 1737 the last Medici grand duke expired in his pigsty of a bed, to the general indifference of his subjects. By now, Florence was completely peripheral in the European chessmatch. The capitals that mattered lay elsewhere: London, Amsterdam, Paris. For the city of Dante and Brunelleschi, the present held only a bitter-sweet nostalgia for its glorious, centuries-old past.

Anna Maria Luisa

Born in 1667, Anna Maria Luisa was exactly seventy years old when Gian Gastone died. On various occasions she had shown herself to be an intelligent and capable woman, and her German subjects had loved and respected her. Although childless, her union with the elector Palatine had been happy from both the sentimental and the intellectual standpoint. Sharing a passion for the arts, she and her husband had established a gallery of some acclaim (although certainly not comparable to the Uffizi or the Pitti) in their Düsseldorf palace; upon his death, she brought many Flemish masterpieces to Florence, further contributing to the already immense family collection. Anna Maria Luisa kept her distance from the court and from public affairs during her brother's reign, and returned to Palazzo Pitti only when Gian Gastone was near to death. Then, in accordance with the pact of 1735, Francis of Lorraine inherited the Grand Duchy and immediately set out for Florence to take possession

On this page, two great paintings acquired for the Medicean collections.
Below: **Madonna with the long neck**, by Francesco Mazzola known as Parmigianino (1503?-1540). Ferdinando purchased the piece in 1698 (Florence, Uffizi).
Bottom: Pieter Paul Rubens, **Consequences of War** (Florence, Palazzo Pitti, Palatine Gallery).
The work originally belonged to Justus Sustermans, Flemish official portrait-painter of the Medici family.

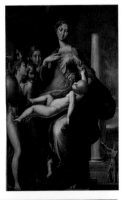

Top: Paolo Caliari known as Veronese (1528-1588), **Holy Family with St. Barbara and Young St. John the Baptist** (Florence, Uffizi). The splendid work was purchased by Cardinal Leopoldo. Above: During the epoch of Ferdinando II the room in Palazzo Pitti that today houses the Neo-classical **Venus** by Antonio Canova, served as antechamber to the Grand Duke's quarters.

of his new state. He remained there just long enough to put all affairs into the hands of an agent of his, the Prince of Craon. In a series of detailed reports to Francis, he painted a gloomy picture of the economic, social and political situation of the Grand Duchy, pointing out the laziness, ineptitude and short-sightedness of the Tuscan ruling classes. All of the public posts were entrusted to the Lorrainese, and in little time Tuscany became an Austrian province.

The electress Palatine decided to retire into the wing of Palazzo Pitti assigned to her, shunning all contact with the newcomers. Anna Maria Luisa passed her remaining time between charitable works and the decoration of the family mausoleum, neglected by her father Cosimo III and by her brother Gian Gastone. She poured an enormous amount of money into the Medici Chapels, and upon her death left a lavish sum to assure its completion.

An inestimable legacy

The last Medici also made an historic decision. Gian Gastone had willed her all of the family possessions, including the works of art accumulated over the centuries. With the so-called "family pact" Anna Maria Luisa forbade the dispersion of the artistic patrimony conserved in Palazzo Pitti, the Uffizi Gallery and other Medicean residences. The text of her decree reads as follows: "The Most Serene Electress cedes, bestows and transfers to His Royal Highness, for him and his grand-ducal successors, all of the furnishings belongings and rarities inherited from the Most Serene Grand Duke her brother, such as galleries, paintings, statues, libraries, jewelry and other precious things, as well as saints' relics, reliquaries, and their decorations in the Palace Chapel, that His Royal Highness is committed to conserve, upon the express condition it be maintained as ornamentation of the State, for public use and to attract the curiosity of foreigners, nor shall it ever be removed or transported outside of the capital and the Grand Ducal State."

With this act was born the finest museum in the world, to this day the most important source of wealth and prestige for the once powerful city. Still, even today the Florentines have yet to realize the tremendous value of this gift. The city almost seems to have forgotten the electress Palatine: it was only recently that the only statue in her honor was situated in the small patch of green next the Medici Chapels, and equally recent was the naming of a stretch of the road running along the Arno in her honor. But if upon her death (February 1743) Anna Maria Luisa had not bound to the city all of the artistic patrimony accumulated by the Medici, the contemporary history of Florence would be much different.

The tombs of the Medici

All members of the House are buried in San Lorenzo, except Piero the Unfortunate, Clement VII, Leo X and Caterina of France. Giovanni di Bicci and his wife Piccarda Bueri repose, along with some of their descendants, in the Old Sacristy. In the New Sacristy one finds the beautiful tombs of Lorenzo, Duke of Urbino and Giuliano, Duke of Nemours, along with the sarcophagi of the Magnificent and of his brother Giuliano.

The last thirty-four Medici, starting with Giovanni dalle Bande Nere and his wife Maria Salviati, are buried in the family mausoleum: the remains of the departed are to be found in the crypt, while the sarcophagi in the mausoleum are merely monuments in their memory. All of the remains were kept intact until in 1791 Grand Duke Ferdinand III of Lorraine decided to open a new entryway into the mausoleum. As the access opened directly into the crypt, the coffins were transported into a second, underground chamber. There, negligence and easy access left them vulnerable to sacrilegious thieves, who systematically plundered them, with the exception of those of the cardinals, of Cosimo III, and Gian Gastone.

In 1857 a commission was appointed to examine the burial site and draft a detailed report on the condition of the remains and of the objects enclosed in each tomb. Once the inspection was concluded, the coffins were returned to the lower crypt, exactly underneath the tombstones of the superior crypt, so that under each tombstone is buried the person to whom it refers. The entrance to the crypt was then sealed: the remains of the Medici have rested in peace ever since.

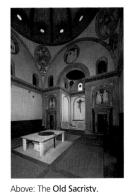

Above: The **Old Sacristy**, designed by Brunelleschi, was the first family tomb of the Medici.

Below: The **Chapel of the Princes** hosts the cenotaphs of the Medici grand dukes. In the foreground: **Night**, one of Michelangelo's most celebrated sculptures, located in the New Sacristy.

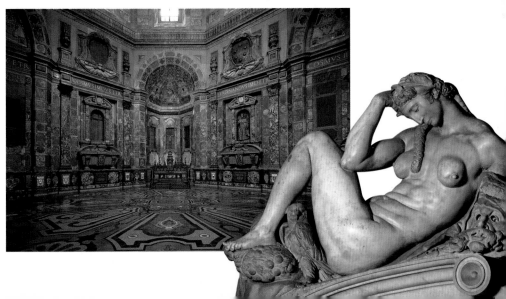

Averardo
(fl. 1286)
|
Averardo
(d. 1318)
falonier 1314
|
Giovenco
(d. 1320)

Nannina

e Elder
464)
a de' Bardi

marquis of Castellina

Piero the Gouty
(1416-1469)
= Lucrezia Tornabuoni

Lorenzo the Magnificent Bianca Lucrezia known as Nannina Giuliano
(1449-1492) (d. 1488) (d. 1493) (1453-1478)
ssi = Clarice Orsini = Guglielmo de' Pazzi = Bernardo Rucellai = Antonia Gorini?

ddalena Contessina Luisa Piero the Unfortunate Giulio
73-1519) (1478-1515) (1477-1488) (1472?-1503) (1478-1534)
cesco Cibo = Piero Ridolfi = Alfonsina Orsini Pope Clement VII

 Clarice Lorenzo Alessandro
 (1493-1528) (1492-1519) (1511-1537) Ottaviano
 = Filippo Strozzi duke of Urbino duke of Florence = Francesca Salviati
 = Madeleine = Margaret of Austria
 de la Tour d'Auvergne Alessandro
 | (1535-1605)
 Caterina Giulio Giulia = Bernardetto Pope Leo XI
 (1519-1589)
 = Henry II of France

Ferdinando I Claudia Elisabeth Francis II Charles IX Henry III Margaret Francis
(1549-1609) = Henry = Philip II of France of France of France = Henry duke of Alençon
 = of Lorraine of Spain = Mary Stuart = Elizabeth = Louise de of Navarre
Christine of Scotland of Austria Vaudemont (Henry IV
of Lorraine of France) princes
 of Ottaiano

Eleonora Caterina Francesco Carlo Filippino Lorenzo Maddalena Claudia
1591-1617) (1593-1629) (1594-1614) (1596-1666) (1598-1602) (1599-1648) (1600-1635) (1604-1648)
 = Francesco = Federico della Rovere
 Gonzaga

lo Margherita Francesco Mattias Anna Leopoldo Ferdinando II = Vittoria della Rovere
3) (1612-1679) (1614-1634) (1613-1667) (1616-1676) (1617-1675) (1610-1670)
 = Edoardo Farnese = Ferdinand Charles
 of Austria
 Marguerite-Louise = Cosimo III Francesco Maria
 of Orléans (1642-1723) (1660-1711)
 = Eleonora Gonzaga

 Ferdinando Anna Maria Luisa Gian Gastone
 (1663-1713) (1667-1643) (1671-1737)
 = Violante of Bavaria = Johann Wilhelm = Anna Maria Franziska
 of Düsseldorf of Saxe-Lauenburg

Index of names

Table of contents